Painting
MOOD &
ATMOSPHERE
in watercolour

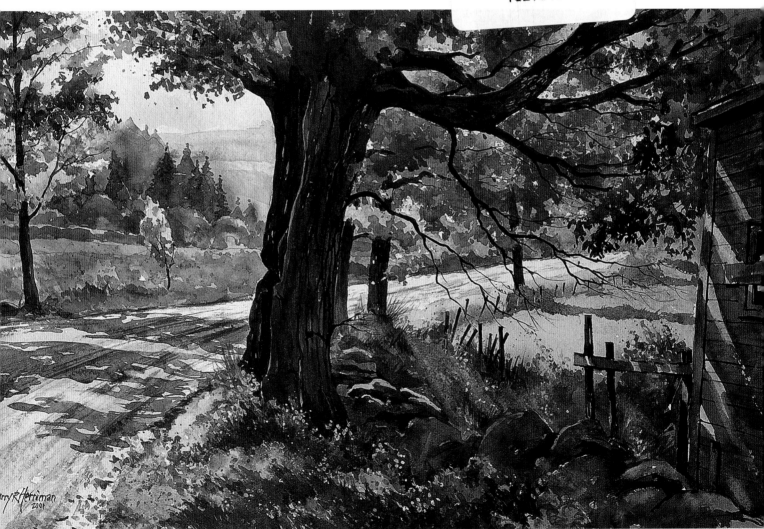

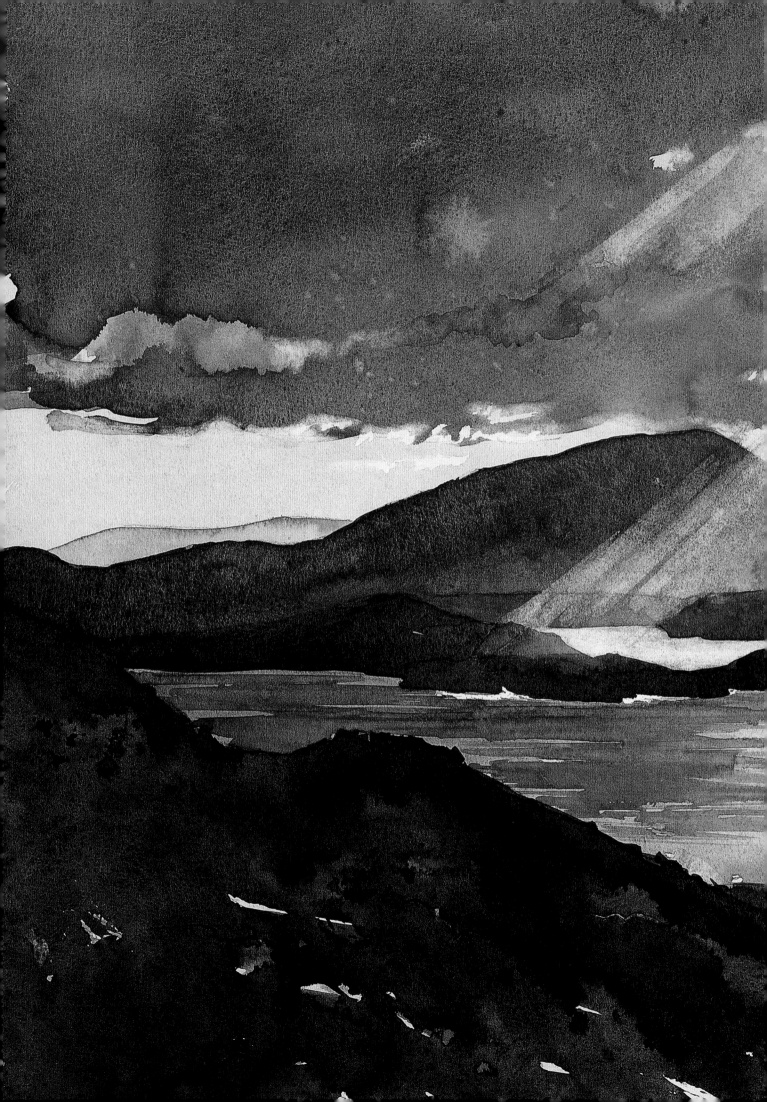

Painting
MOOD &
ATMOSPHERE
in watercolour

Barry Herniman

SEARCH PRESS

This edition published in 2020

Search Press Limited
Wellwood, North Farm Road,
Tunbridge Wells, Kent TN2 3DR

Originally published in 2004 as:
Watercolour Tips and Techniques: Painting Mood and Atmosphere

Text copyright © Barry Herniman 2004, 2020

Photographs by Charlotte de la Bédoyère,
Search Press Studios

Photographs and design copyright ©
Search Press Ltd. 2020

ISBN: 978-1-78221-675-9

SUPPLIERS
If you have difficulty in obtaining any of the materials and equipment mentioned in this book, please visit the Search Press website for details of suppliers: www.searchpress.com

Dedication

To Sally, my other half, and our four new niths who are a constant inspurration – when they are not running riot.

Page 1

MAPLE HILL DRIVE, VERMONT
51 x 31.5cm (20 x 12¼in)

This lovely backcountry lane has some of the oldest maples in Vermont and what a delight they are. I spent a whole day painting in this area with the fall colours everywhere – magic!

Page 2–3

STRONG LIGHT OVER MUCKISH, FROM GARNIAMOR, DONEGAL
52 x 35.5cm (20½ x 14in)

A winter's day walk to the top of Garniamor yielded this magnificent view across the bay to Muckish. The clouds were pulling back and shafts of sunlight lit up the water; one of my favourite subjects.

Opposite

MIDDAY SHADOWS, MINORI
30.5 x 22cm (12 x 8½in)

A quick painting, on site, to catch the strong light on the sides of these coloured houses. The light on the Amalfi coast is strong and vibrant; you really have no choice other than to paint it!

PUBLISHERS' NOTE

All the step-by-step photographs in this book feature the author, Barry Herniman, demonstrating how to paint with watercolours. No models have been used.

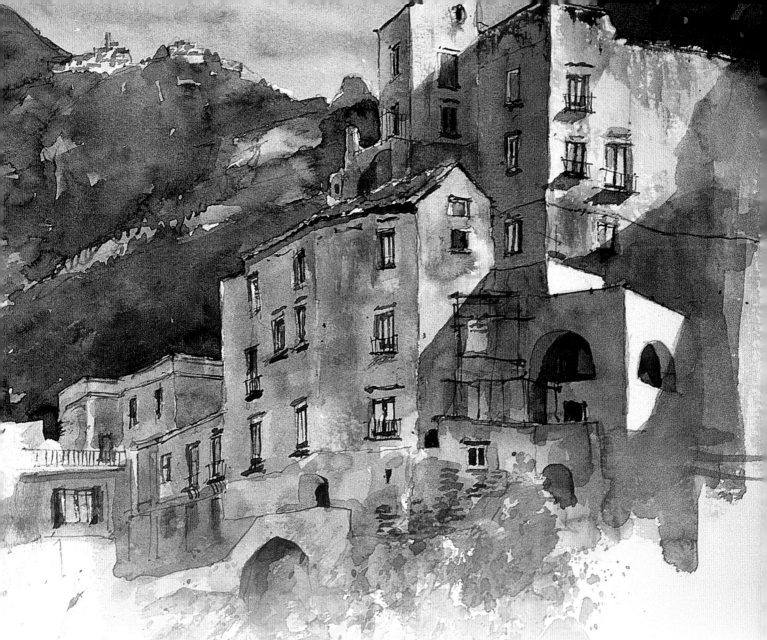

CONTENTS

STEP-BY-STEP DEMONSTRATIONS

INTRODUCTION

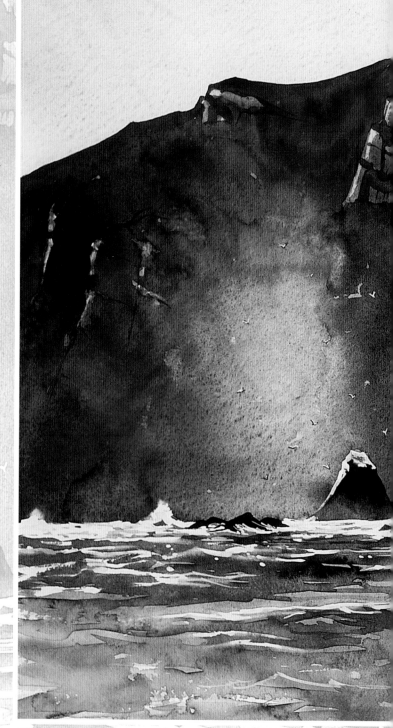

When I first started painting, my intention was to produce a worthwhile facsimile of the scene in front of me. Basically, this was fine, and I learnt a lot of my painting craft that way. As time went on, however, I became less enamoured with creating just 'straight' paintings, and I started to explore other ways of putting paint on to paper.

What I really wanted to do was to capture the essence of a scene, 'the sense of place', and to inject the subject with that extra something . . . mood and atmosphere! Mood comes in many shapes and forms, and is open to individual interpretation. Each of us has our own perfect time of day, a favourite season or certain weather conditions that set our senses alight. When these elements prevail, that is the time to get painting.

Every landscape is dependent on light. Whether it is diffused through a soft hazy morning mist or coloured with the intense glow of a hard-edged sunset, light is the main governing factor. How often have you passed by a scene that is totally familiar to you, then, one day, the light changes or some unusual weather sets in and wham! the ordinary becomes the extraordinary?

To me, that is what painting is all about, and I call it 'art from the heart'. Before I start to paint, I ask myself what it was that grabbed my attention and made me look twice. When I have answered that question it is then a matter of deciding how to capture it.

When it comes to painting, try not to be too literal with the colours, but rather use mixes that respond to your feelings. Too much time and energy can be used mixing just the right green only to be disappointed with the rather static result that the colour mix produces.

Let the watercolour have its head and allow it to move about of its own accord. This can be quite scary, but I am sure you will be surprised at some of the results.

This is what I am endeavouring to impart to you with the projects in this book – to move away from just realism, and inject your paintings with mood and atmosphere.

So, good luck, and get moody!

6

WHEELING IN THE MIST, HORN HEAD, DONEGAL
68 x 42cm (26¾ x 16½in)

You really cannot get moodier than Horn Head, a great slab of rock on the northern tip of Donegal. I have witnessed the peninsula in all weathers, but on this day I hired a boat to take me to the foot of the cliffs to get the view looking up at them.

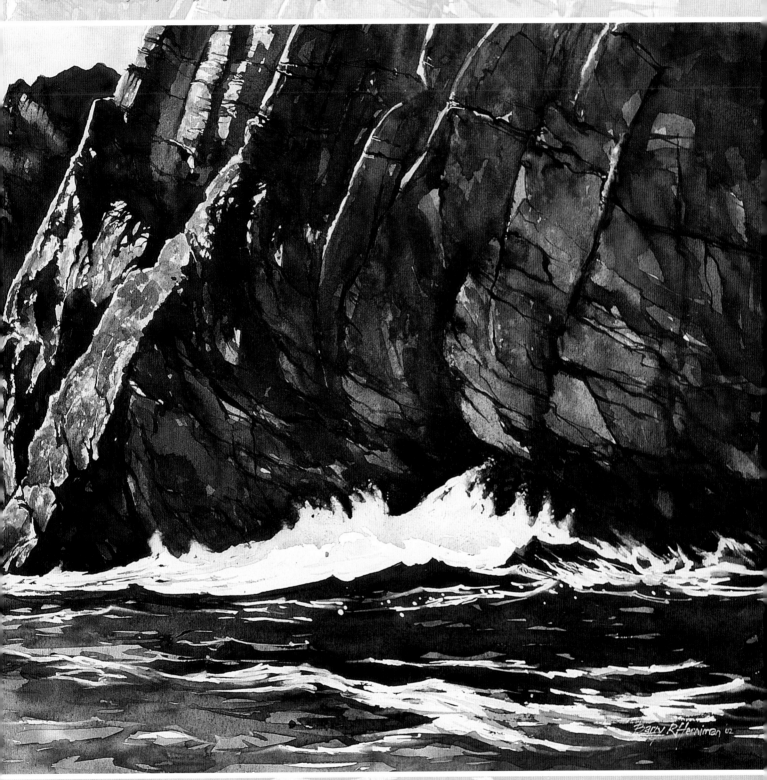

Because we were so close to the rock face, the sun was shielded behind cliff tops, but it caught the leading edge of the head which counterchanged beautifully with the shadowed cliff face in the distance. Seagulls were wheeling about in the up currents of the early morning mist. It made for a very exhilarating day, which inspired me to do a series of paintings of this wild Irish coast.

MATERIALS

In today's painting world there is a whole host of materials to suit all tastes and pockets. This can become a problem in itself: because choices are so great it can be a nightmare to sort out which materials are right for you. For this reason art shows and fairs are a great place to talk to manufacturers and try out the materials before you shell out your hard-earned cash; 'try before you buy' is a good policy to adopt! Also keep your equipment to a minimum: buy less but buy the best.

PAINTS

It is paint that brings light and life to a picture and the colours I use have changed over the years as I am always striving to get transparency into my work. With this in mind, I always use artist's quality watercolours which have the purest pigments available. I have tended to shy away from the earth colours – raw sienna, yellow ochre and the browns – as they are slightly opaque. I never use Payne's gray or black, and sepia and indigo are also rather heavy, but I still love burnt sienna. Mixed with French ultramarine, burnt sienna makes a great dark.

When choosing a colour the manufacturers colour chart is a good first point of reference, but there is no substitute for getting to grips with the pigment and seeing how it works for you. Colours can also vary between different brands so, if possible, it is best to try them out first.

I use 15ml tubes of watercolour and squeeze the paint directly into the palette. I do not use pans as I never seem to get the same richness of paint as I do with freshly squeezed paint.

PAINT COLOURS

My palette for this book consists of rich, transparent colours: you can subdue a bright colour, but just you try to get life into a dull one!

PALETTES

When working in the studio I use a variety of different palettes. My favourite is my trusty Robert E. Wood palette (see below) which my good friend, Bob Blakely, sent me from the USA. It has deep paint wells and a large mixing area with a central dam. When painting large washes, I like to use ceramic palettes with deep wells to hold lots of pigment.

NEW PLASTIC PALETTES

Paint tends to 'bead' when you mix it on a new plastic palette, due to the very smooth surface. Gently rubbing household liquid scourer on the mixing areas will remove the surface shine and allow your mixes to hold together.

BRUSHES

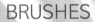

Kolinsky sable brushes are a joy to use but I find I wear down the points rather quickly (especially the way I paint!) and once you lose the point, the brush loses its appeal. The price of some of these brushes can be astronomical but there are some super sable/synthetic brands on the market which are exceptionally good – and at a fraction of the cost of sable brushes. Not only do these have the good colour-carrying capacity of pure sable brushes, they also have the durability of the synthetic materials.

The brushes used for the projects in this book, from right to left: Nos. 16, 12, 10, 8 rounds; No. 3 rigger; hoghair brush for lifting out; and my well-worn sable (I use that term very loosely!) for applying masking fluid.

PAPERS

There are some super papers on the market and most are at very affordable prices. I have always tended to paint on 300gsm (140lb) paper, stretching it before use. But now I am using 640gsm (300lb) more often; with certain brands I can tape a piece of paper straight onto a board and start painting without stretching. Heavy papers are great for painting outdoors and for demonstrations as they do not buckle and bend as do the lighter weights. However, they do bow slightly under the weight of my washes!

Watercolour paper usually comes with one of three main surface textures: Hot Pressed, or HP, is very smooth and is ideal for high detail and fine line work; Not (short for not hot pressed) paper, also called cold-pressed, has a semi-rough surface and is a great all-rounder; and Rough has a very pronounced surface or 'tooth', which is superb for textures and dry brushing.

Another surface I particularly like is Torchon; this has a dimpled rather than a rough surface and is very good for large wet washes.

BOARDS

My boards are made from 25mm (1in) thick marine plywood which I find stronger and lighter than MDF (medium density fibreboard). I coat them with clear varnish to seal the surface, leaving the brush strokes to create a 'tooth' for the tape to adhere to when I stretch lighter weight papers.

An alternative to wooden boards are plastic laminate boards. This type of board is useful, but not for stretching paper. It has no grip for the tape and, more often than not, the tape will lift off as the paper dries. Overcome this problem by roughly brushing varnish over the surface to create a tooth.

10

I find it useful to obtain swatches of different types of watercolour paper and see how my brush strokes work on each surface texture.

ANTI-SLIP FABRIC

This is a very useful material, especially when painting outdoors. Taped onto my painting board, it allows me to rest a watercolour block or sketchbook directly onto an inclined surface without it slipping off. I can also move my painting every which way without undoing the easel.

OTHER EQUIPMENT

The other equipment in my work box includes the following items:

PENCILS Graphite sticks; grade 2B to 8B I use these for drawing quick tonal sketches with plenty of oomph (a technical word!).

WATER-SOLUBLE COLOURED PENCILS A recent addition to my work box which I find useful for quick, on-the-spot sketching.

CLUTCH PENCIL; 2B LEAD This goes everywhere with me. I am rather heavy handed when sketching and tend to break leads quite frequently, so I also have a small lead sharpener which enables me to keep a sharp point with minimum fuss.

MASKING FLUID While some students apply it with all the finesse of a sledge hammer, this is very useful if used judiciously.

SPRAY DIFFUSER BOTTLE I really would be lost without my 'squirt bottle'. Not only does it keep my paints nice and moist, but I use it to move paint around on the paper to create all sorts of effects.

GOUACHE Sometimes known as opaque white, this is great for 'ticking in' those final details that add sparkle to the finished painting.

KITCHEN PAPER I use this for lifting out and general purpose cleaning. Avoid face tissues: these are often impregnated with lotions which, although good for the skin, make the paper greasy and unworkable.

CRAFT KNIFE A good tool for scraping out colour and general purpose use, but do not carry it in your hand luggage when flying!

SKETCHBOOKS I keep a journal of my travels in hardbound sketchbooks filled with rough watercolour paper. I paint *en plein air*, with the emphasis on speed and vitality, rather than technical expertise, to record all those special places I visit. It is quick and immediate, and I really get a lot of pleasure from sketching them. When I want to capture a wide view, I often paint right across the spine.

WATERCOLOUR FIELD BOX After years of painting outdoors with a rather heavy and expensive field box (and with curious students put off by the price of it), I designed one of my own with the help of my friend Shelley. My paintbox is a sturdy, lightweight compact box that has eight deep wells for mixing washes plus a removable central compartment for paints in both tube and pan format. It is made from durable, high impact plastic that is easy to clean. When closed it measures 11cm (4¼in) square and 3.25cm (1¼in) deep.

Graphite sticks.

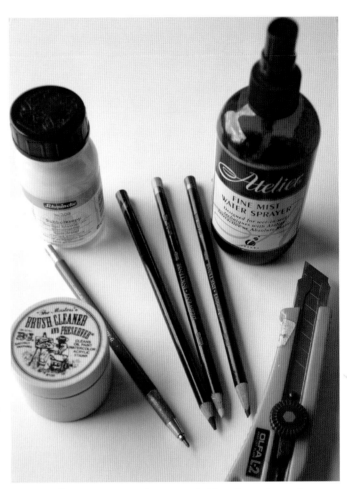

Masking fluid, clutch pencil, water-soluble coloured pencils, spray diffuser bottle, craft knife and brush cleaner.

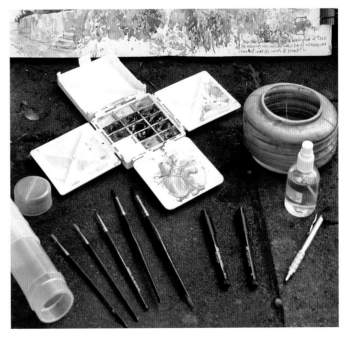

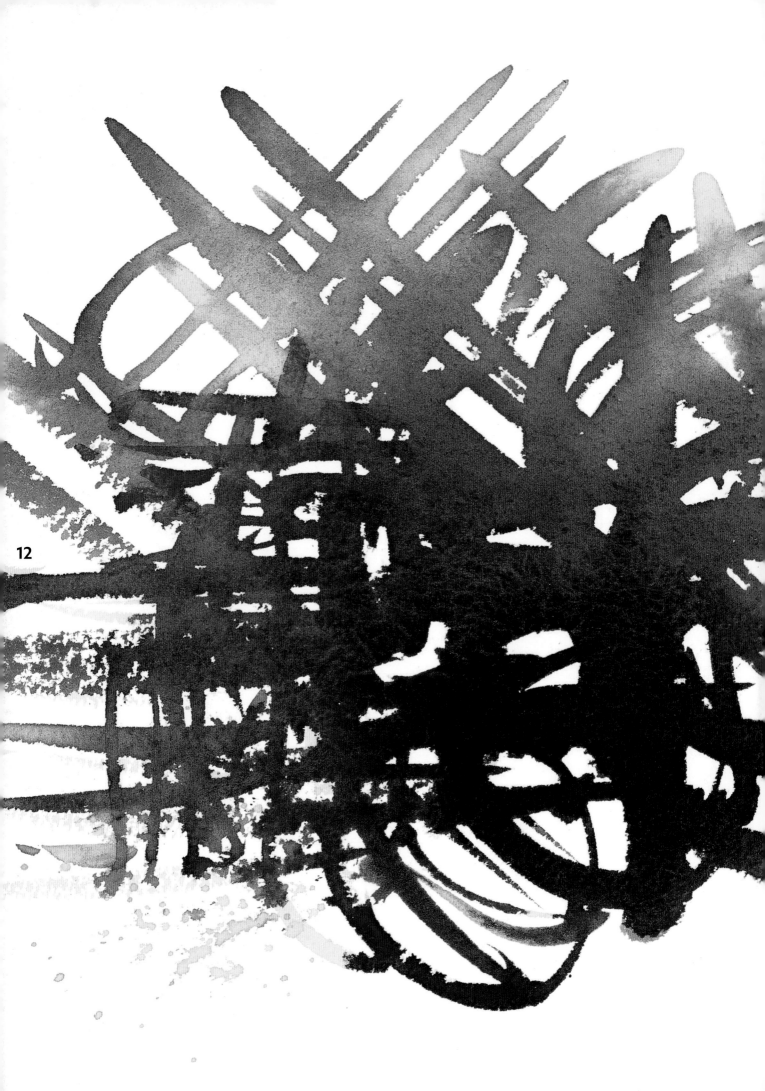

12

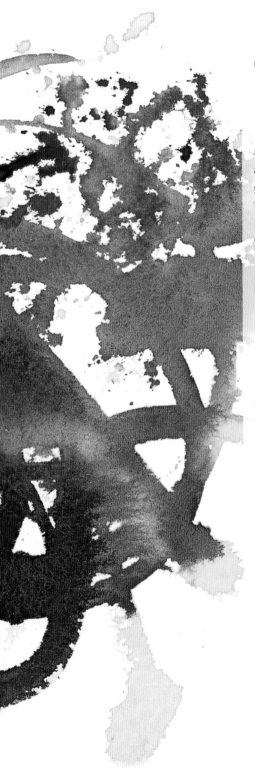

COLOUR MIXING

I could fill a book just on colour and colour mixing, but, rather than get bogged down in a whole lot of technical jargon I want to give you a few basic tips on colours and some of my favourite mixes. Remember that nothing is set in stone and each picture should dictate the palette of colours needed to grab that particular mood.

At a quick glance, and before you read on, how many colours do you think went into the doodle opposite – six, eight, ten maybe? Well, there were just three! A blue (French ultramarine), a red (alizarin crimson) and a yellow (Winsor yellow).

Doodles like this show the multitude of colour mixes and tones you can create from just a few colours. On the right I have pulled out some of the colours and hues that are mixed within this doodle to give you an idea of the combinations. Simple exercises like this enable you to get to know your colours and how they work together. This only comes with practice – so get doodling!

French ultramarine, Winsor yellow and alizarin crimson.

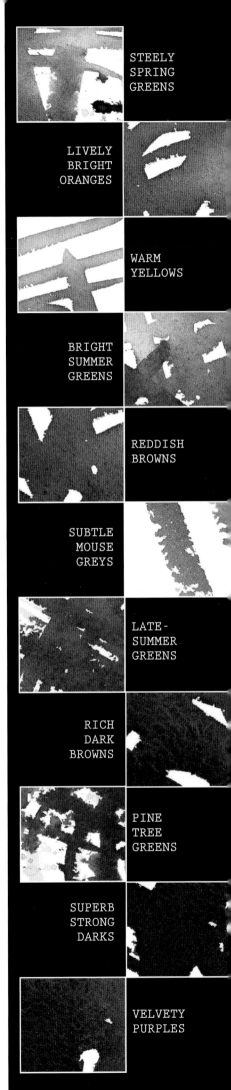

STEELY SPRING GREENS

LIVELY BRIGHT ORANGES

WARM YELLOWS

BRIGHT SUMMER GREENS

REDDISH BROWNS

SUBTLE MOUSE GREYS

LATE-SUMMER GREENS

RICH DARK BROWNS

PINE TREE GREENS

SUPERB STRONG DARKS

VELVETY PURPLES

THREE COLOURS

Try this exercise yourself. First mix three generous wells of colour into a top-of-the-milk consistency – one yellow, one red and one blue – any colours you fancy, it does not matter. Fully load a large round brush with the yellow, then, with your paper at 25° to the horizontal, make some lovely loose brush strokes across the paper. Clean your brush and do the same with the red, taking some of the strokes across and into the yellows, then watch them start mixing on the paper. Don't go back into it with your brush or you will spoil the mixing process. Now do the same with the blue, making marks over both the yellow and the red. While the paper is still wet, tilt the painting board backwards and forwards and watch out for the 'happenings'. You will be staggered at the wonderful array of colours that appear before your eyes. This is the basis of all the colour mixing in this book, mixing loads of lovely bright transparent colours right there on the paper!

Having seen what can be achieved using the three primary colours on the previous pages, try some different combinations. For the example on the top right I have used an altogether quieter palette – aureolin, rose madder genuine and cobalt blue. Look at the wonderfully subtle colours that can be achieved with this trio of colours. Soft but still very vibrant, there are some lovely shadow areas in there.

If you use the trio of Indian yellow, scarlet lake and phthalo blue, you will get the much stronger mixes shown bottom right.

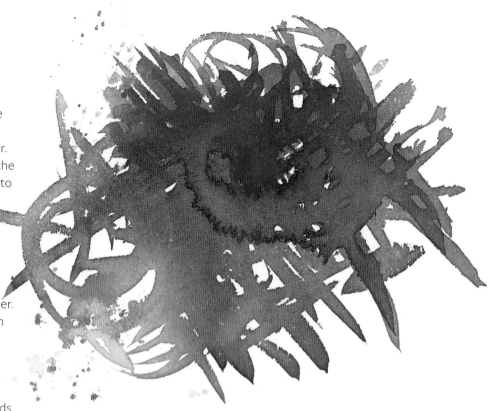

QUIET PALETTE
Cobalt blue, aureolin, rose madder genuine.

STRONGER PALETTE
Phthalo blue, Indian yellow, scarlet lake

NINE COLOURS

Now if you take all nine colours – the three yellows, reds and blues – and mix and match them, just think of the endless possibilities you could get. Some of these combinations are shown below. All this with just nine colours. You may never use pre-mixed green again – welcome to the wonderful world of colour!

Alizarin crimson and Indian yellow

Aureolin and manganese blue

French ultramarine and alizarin crimson

My palette

When you first set out to buy colours, the first thing that becomes evident is that there is a staggering array of different hues across the whole spectrum. Pick up a manufacturer's colour chart and prepare to be dazzled! What I have done is to whittle down my colours to a basic minimum and add the odd exotic colour here and there when the situation calls for it.

My basic colours are cobalt blue, French ultramarine, phthalo blue, Winsor yellow, aureolin, Indian yellow, rose madder genuine, madder red dark, brown madder, also manganese blue (or cerulean blue), quinacridone gold and manganese violet.

Phthalo blue and Indian yellow

French ultramarine and burnt sienna

Winsor yellow and cobalt blue

French ultramarine and brown madder

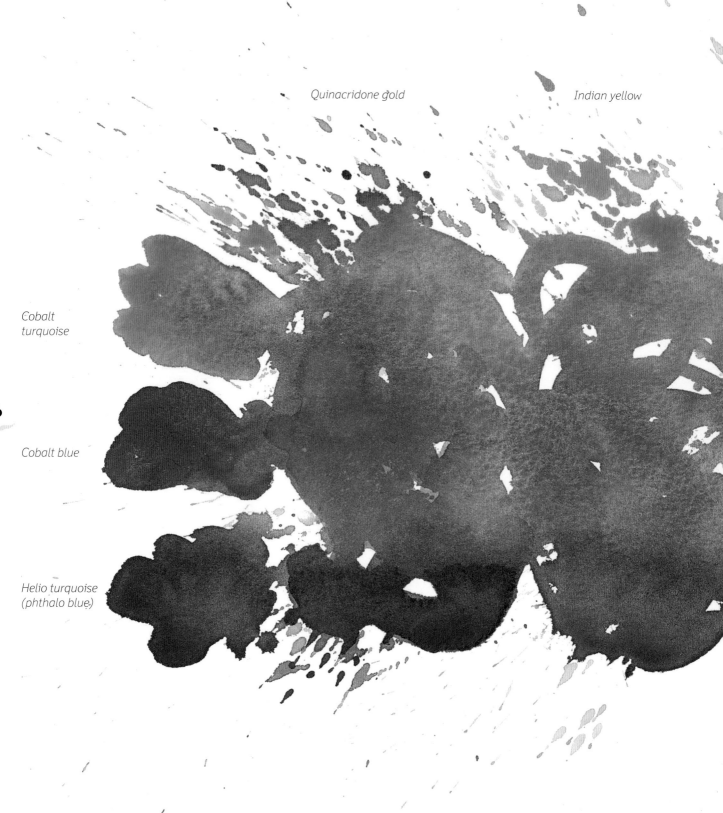

Quinacridone gold

Indian yellow

Cobalt
turquoise

Cobalt blue

Helio turquoise
(phthalo blue)

GREENS

When we think of the countryside, and particularly the English countryside, the colour green is at the forefront. All the different hues that make up our green and pleasant land are incredible; but you try and convince students of that fact! Greens have a reputation for being complicated to mix, but if you do have a hang-up about greens I hope this section will open up some exciting possibilities and get you embracing these wonderful colour mixes.

My first forays into watercolour were – to be kind – absolutely abysmal. To make matters worse, my tutor's method of using tube colours for greens almost put me off watercolour altogether. Even when mixed with another colour, the result always ended up predominantly that overpowering green tube colour.

So I went on a search for alternative artists both home and abroad who would produce lifelike greens without using just green tube colours. I then started to mix my own greens using a series of blues and yellows and then modifying those mixes with other colours to get alternative shades and nuances. Now I have no greens in my palette at all and mix all my greens.

*Pure yellow
(Winsor yellow)*

*Pure yellow
(Winsor yellow)*

Indian yellow

Quinacridone gold

Green mixes

This chart of greens will give you a clearer idea of the multitude of greens you can get by just mixing three yellows and three blues. I worked my yellows in swirls down the page, then moved my different blues across the page into the wet yellows to produce those lovely greens. Notice all the nuances of the different greens within the mixes.

SEASONAL ATMOSPHERE

Trees make up so much of the countryside that if you want to be a landscape artist, you will have to paint trees in some form or other. The following pages show four quick paintings that give you some basic colour mixes for trees during the different seasons.

SPRING

After the bareness of the winter, the bright shimmer of that first spring green in the trees is a joy to behold. How to capture that fragmentary feel of the new leaves bursting forth was always a real headache for me as 'painting ' it in the traditional way always seemed to come up short.

So I started experimenting with a flicking process where the paint would fall in a very random way and all the colours would mix on the paper. This produced the sparkle and light I was looking for.

I started off with my light greens by flicking the aureolin onto the paper and then adding the manganese blue into it. That gave me my basic sharp spring greens. I then followed up with my Indian yellow and cobalt blue mix. The bluebells used a mix of French ultramarine and manganese violet, which was flicked onto the paper. The tree trunks and branches were a mix of alizarin crimson and French ultramarine.

18

MIXES USED IN THIS PAINTING

Aureolin *Manganese blue* *Indian yellow* *Cobalt blue*

French ultramarine *Manganese violet* *Alizarin crimson* *French ultramarine*

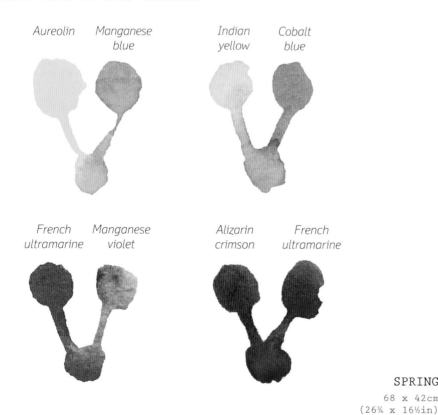

SPRING
68 x 42cm
(26¾ x 16½in)

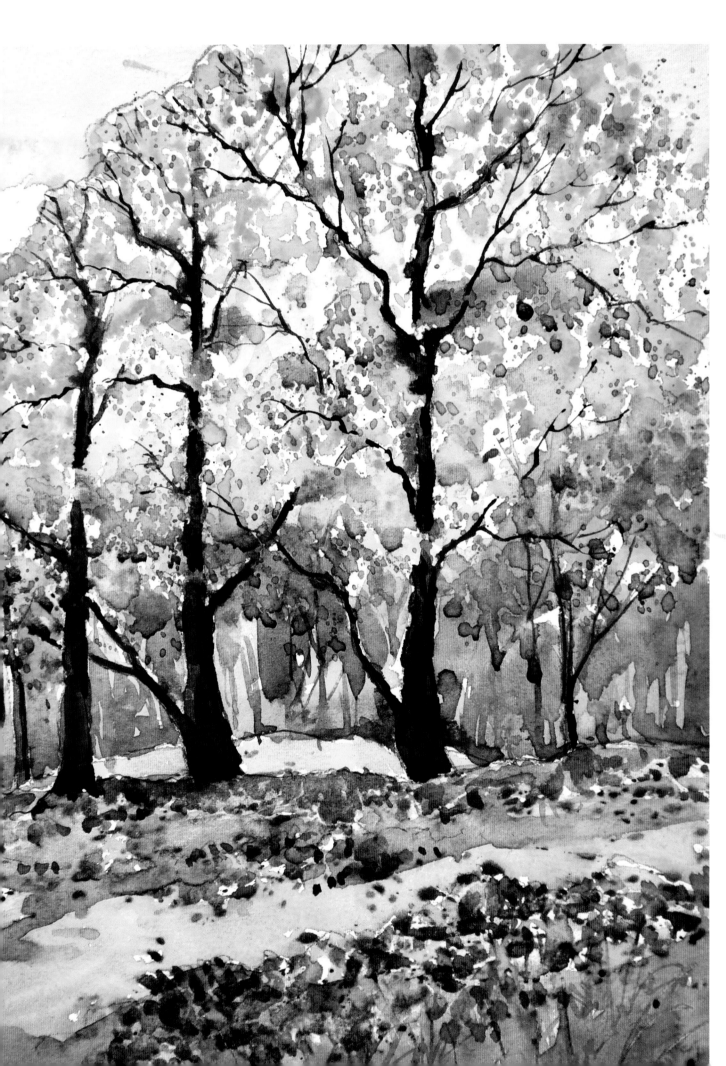

SUMMER

The first thing you will notice from this painting is how different the technique is from the spring painting. Here we are faced with full summer foliage in all its verdant glory. Admittedly, I have used some flicked paint in the background trees but the foreground is predominantly painted with larger brush strokes to emulate the lush foliage. Notice also that apart from the lower trunks the majority of the tree is hidden behind the curtain of leaves.

My green colour mixes for summer are much more 'rounded' in stark contrast to the rather 'acid' greens of the spring. I started off by flicking in an Indian yellow and cobalt blue mix into the background trees, then overlaid a cobalt blue wash once it had dried.

I then started to build up the lightest greens with a mix of aureolin and manganese blue. The mid section was a mix of Indian yellow and cobalt blue. Those lovely velvety dark greens were made with the two helio turquoise mixes (this paint is also called phthalo blue), taking care to paint round the lighter greens. The trunks were the madder brown and French ultramarine mix.

MIXES USED IN THIS PAINTING

20

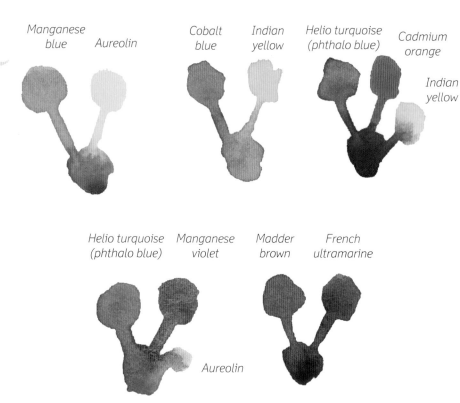

Manganese blue Aureolin

Cobalt blue Indian yellow

Helio turquoise (phthalo blue) Cadmium orange

Indian yellow

Helio turquoise (phthalo blue) Manganese violet

Madder brown French ultramarine

Aureolin

SUMMER
68 x 42cm
(26¾ x 16½in)

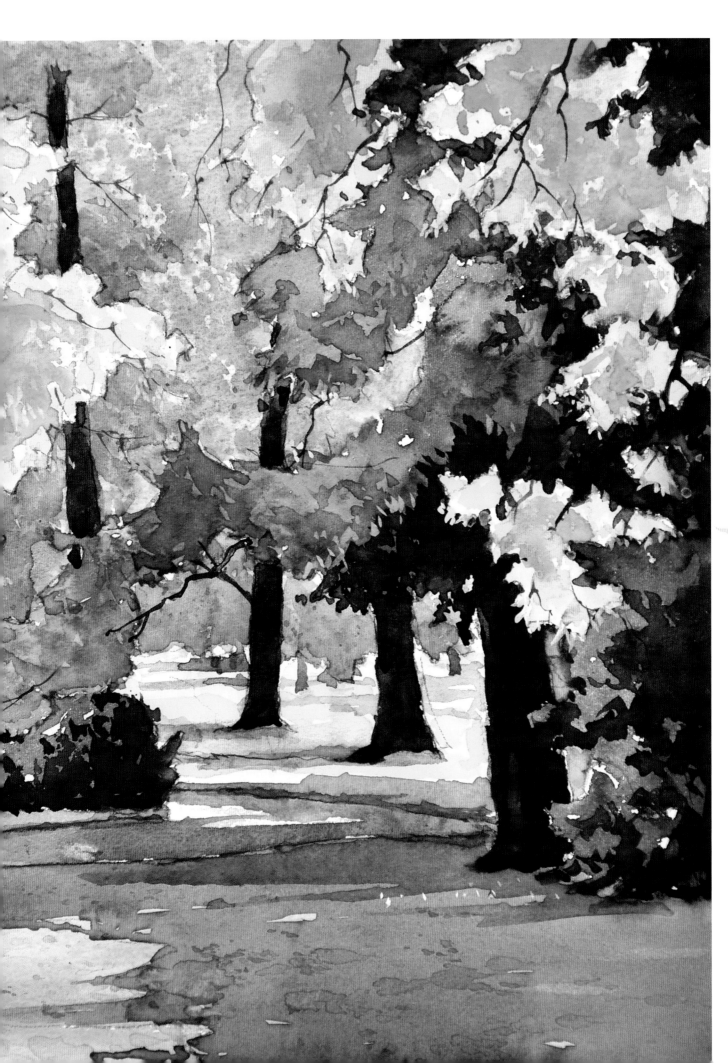

AUTUMN

And now for something completely different! Autumn is here and all those lovely russet colours now imbue the scene. This is a really fun picture so keep your colour mixes nice and clean to get that super autumnal feel. This is where the spattering technique really comes into its own.

Start by grabbing all your lightest colours and use the mix of Indian yellow and cadmium orange for the foliage – don't forget to use the same colours for the leaves on the ground. Then build up the stronger reds with a mix of rose madder and manganese violet. For the light-hued background trees, I used the two yellow–blue mixes below. For the trunks and background trees, I used the dark French ultramarine and cadmium orange mix.

MIXES USED IN THIS PAINTING

Indian yellow *Cadmium orange* *Rose madder* *Manganese violet* *Manganese blue* *Aureolin*

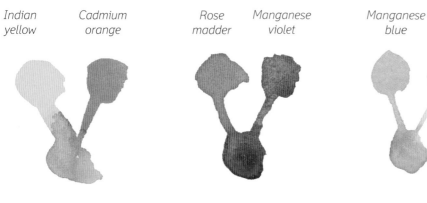

Cobalt blue *Aureolin* *French ultramarine* *Cadmium orange*

Manganese violet

22

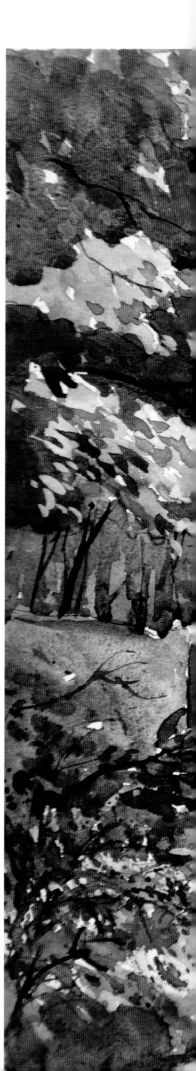

AUTUMN
68 x 42cm
(26¾ x 16½in)

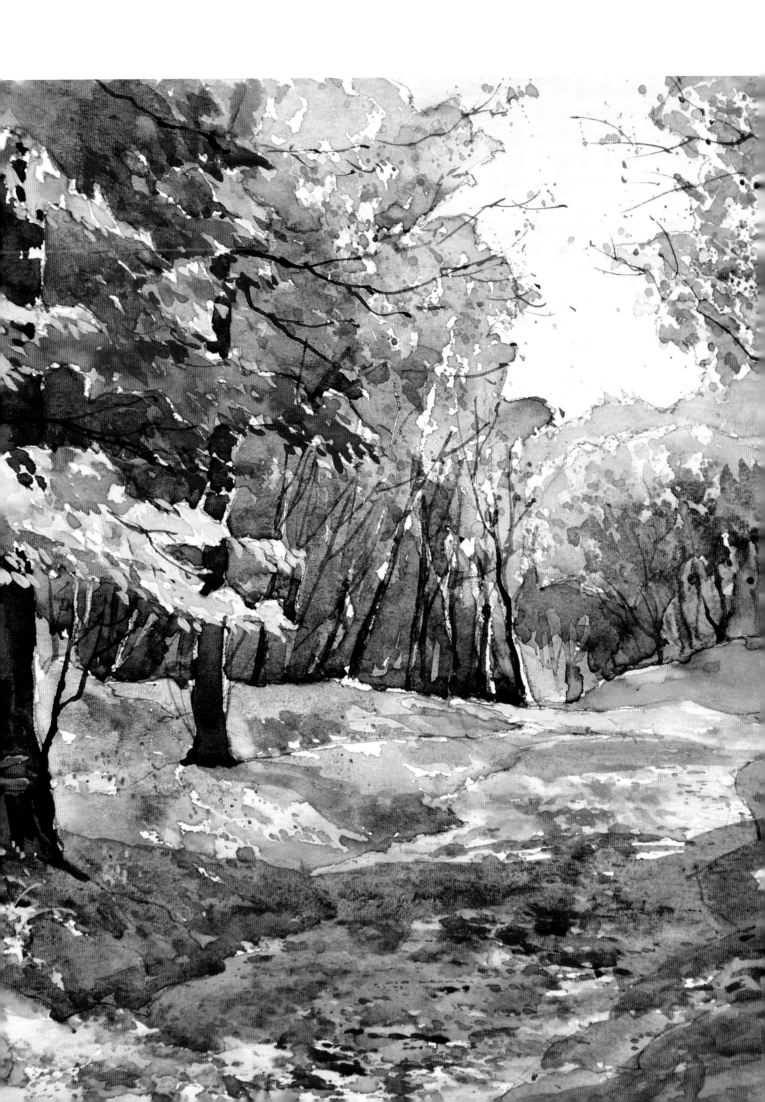

WINTER

Moving from one extreme to the other, this painting provides a stark contrast to the autumnal colours on the previous pages. Apart from the hints of orange in the field stalks, this painting is almost monochrome. I masked out the tops of the few main branches to retain the whites of the snow.

I set off by flicking in the background trees with the cobalt blue and manganese violet mix. Next, I painted a light wash of a manganese blue and cadmium orange mix for the background field; building up the strength as you come forward with addition of manganese violet. The closer we got to the foreground, the more I started to spatter the paint. The left-hand side of the ground used the slightly colder mix of cobalt blue, cadmium orange and a touch of manganese violet.

24

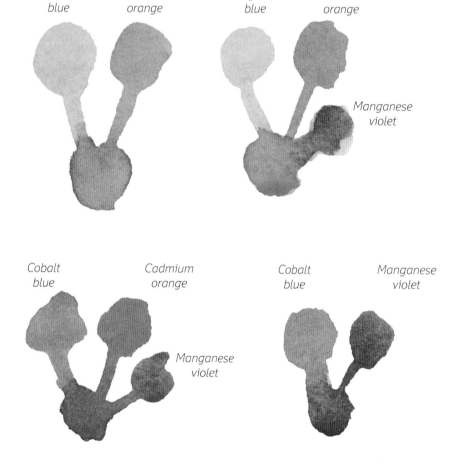

Manganese blue

Cadmium orange

Manganese blue

Cadmium orange

Manganese violet

Cobalt blue

Cadmium orange

Manganese violet

Cobalt blue

Manganese violet

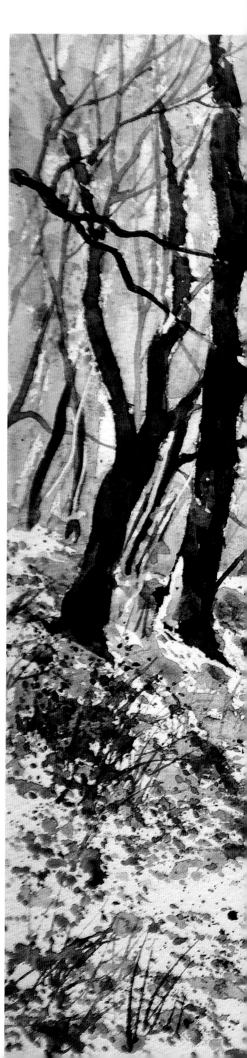

WINTER
68 x 42cm
(26¾ x 16½in)

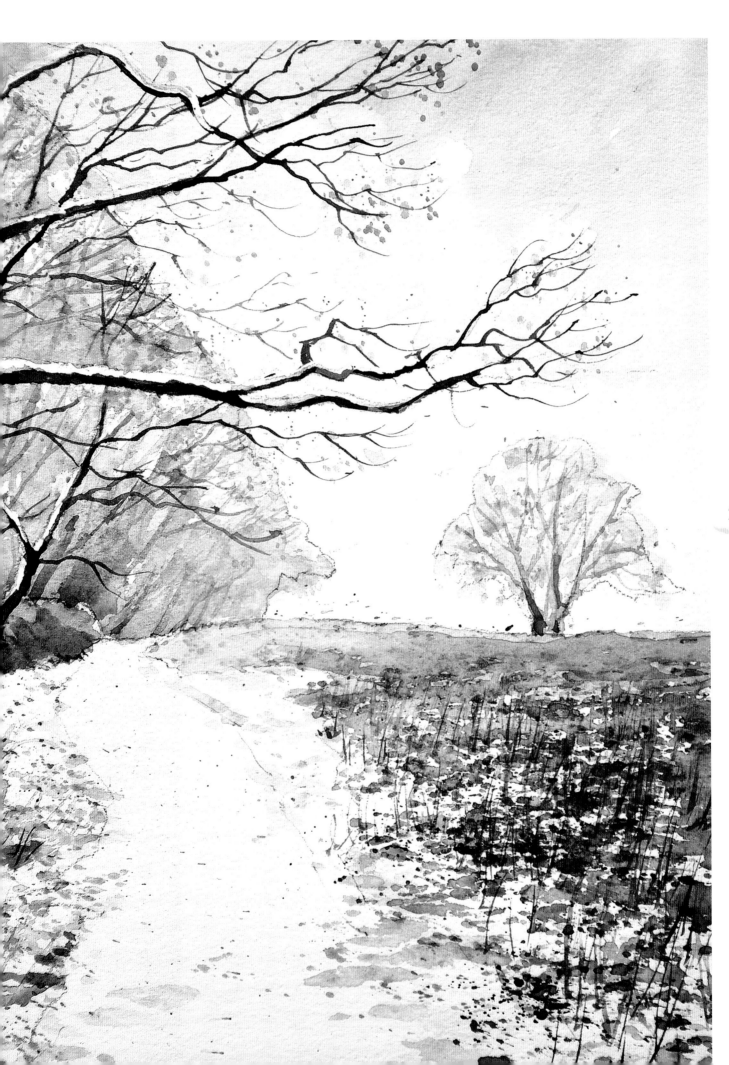

CAPTURING THE MOOD

There is mood and atmosphere all around you, even on a bright sunny day – depending where you look! This was the case with this rather tranquil scene at Faversham in Kent. I went to the boatyard and there were a multitude of wonderful subjects all in the glare of the afternoon sun. Boats, buildings and water all in sharp relief and all very colourful. When I looked over my shoulder, however, the scene changed dramatically; I was now looking into the sun, *contra jour*, and all those bright colours were severely muted, but there were some beautifully highlit shapes counterchanged (an artistic term that simply means placing very dark areas near very light areas to heighten contrast and impact) against some velvety details. Painting a scene *contra jour* bleaches out a lot of the colour, but it does produce a moody scene where shapes and shadows merge together.

I took some reference photographs, but, mindful of the fact that I had to wait to see the results, I set about doing a quick tonal sketch to work out the main lights and darks and the mid tones. I then painted the loose colour sketch (opposite) *in situ* as a demonstration of how to paint highlights without using masking fluid.

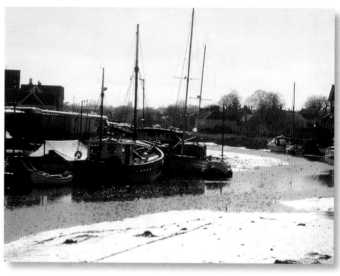

SOURCE PHOTOGRAPH
One of the photographs taken on my visit to the boatyard at Faversham. Beware when taking any photographs into the sun, as the lights go white and the shadow areas go black.

26

TONAL SKETCH
This tonal sketch was worked up using a 4B water-soluble pencil.

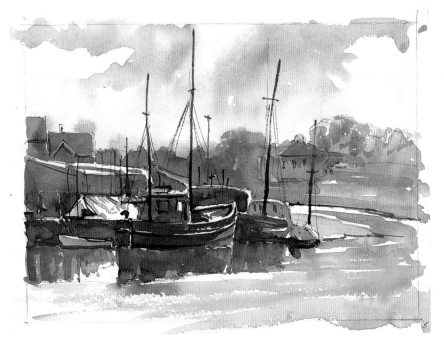

QUICK COLOUR SKETCH

This quick sketch demonstrates how you can paint a scene directly, without using masking fluid. I just painted around all the highlights as I worked down from the sky. It is very rough and ready, but I think it gets across the prevailing mood of the scene, and it also loosened me up to do the finished painting.

MOORED UP FOR THE DAY - FAVERSHAM, KENT
46 x 34cm (18 x 13½in)

This small watercolour, built up with a series of wet overall washes, was painted when I got back to my studio. The highlights were masked out so I did not have to worry about reserving them and I could concentrate on getting the washes down.

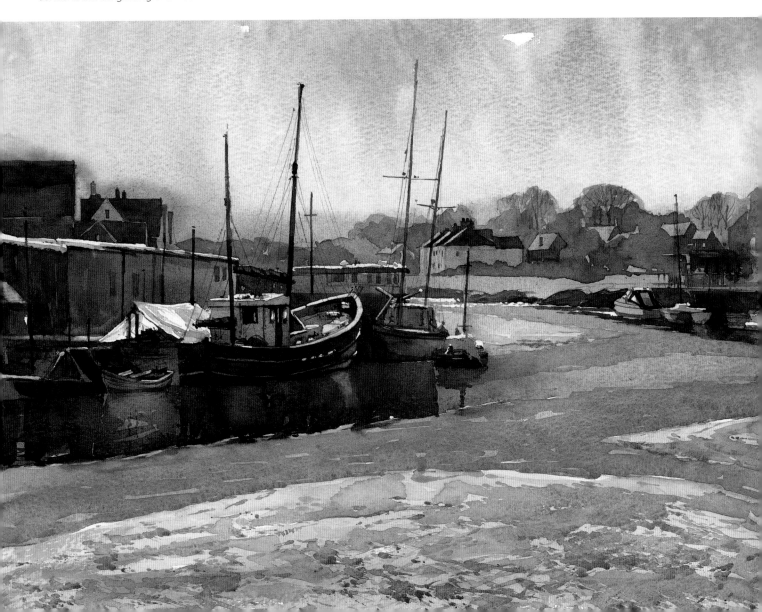

When you have found a scene that excites and inspires, all you have to do is paint it! While the adrenaline is running, I sometimes dash off a quick watercolour painting just to see how it works and comes together. Here are two versions of the same scene, one painted on site, the other worked up in my studio.

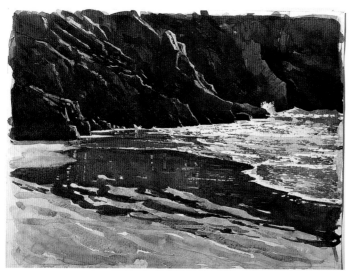

RECEDING TIDE, ST CATHERINE'S ROCKS
40 x 30cm (15¾ x 11¾in)

This painting was quite small, but I had a great time getting all the rock colours moving and mingling together, and highlighting their edges to give them a little lift.

I experimented with masking fluid for the highlights in the water to get the sparkling effect and built up the colour densities of the sea with a succession of transparent glazes.

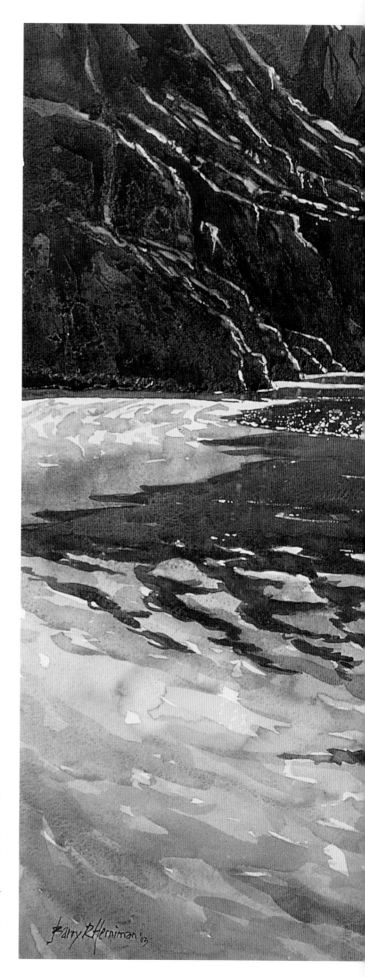

RECEDING TIDE, ST CATHERINE'S ROCKS
77.5 x 66cm (30½ x 26in)

Having completed the small painting above, I was all fired up to paint this much larger version – with a few modifications. I was happy with the colour combinations in the rocks and the sea, but the overall format was not what I wanted. I felt that a larger expanse of foreground beach would give the scene a greater air of solitude. Having worked up various pencil compositions, I decided on this almost-square format. It has a good amount of wet and dry sand in the foreground that helps lead the eye into the painting, and this also acts as a foil to the darkness of the sea and rocks.

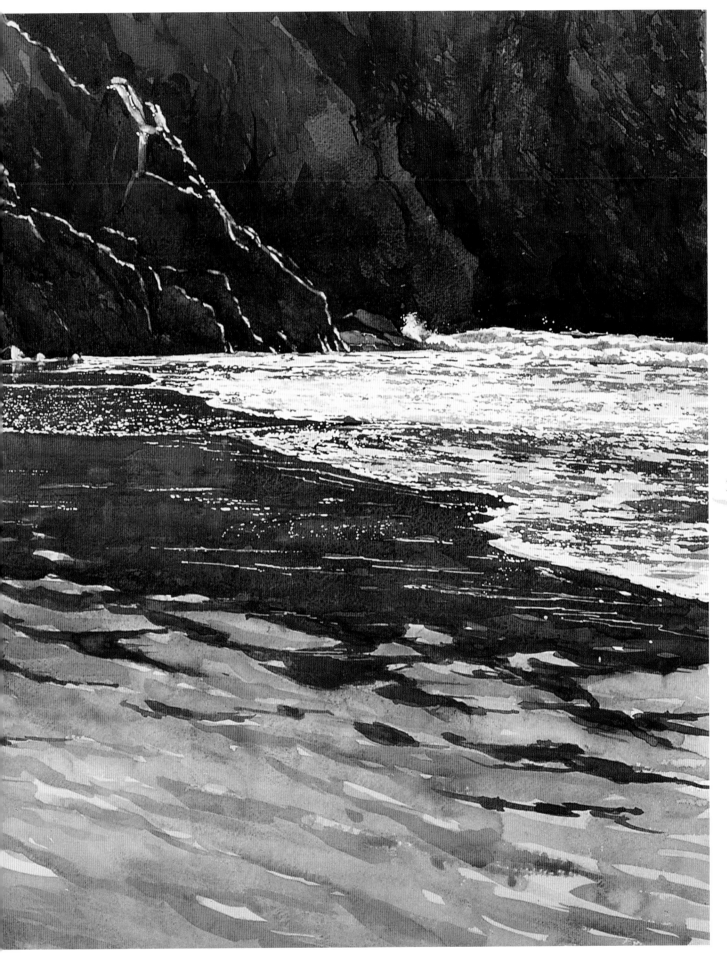

MAGIC OF THE MOMENT

It is not always possible to sit and paint a scene that really grabs you, but, when you can, it is a bonus. I was very lucky with this scene of the Roman Bridge at Penmachno, North Wales. While giving a painting demonstration one morning, I was able to get the magic of the moment down on paper. In this very quick, direct painting, I was intent on capturing certain light qualities rather than concentrating on detail. The morning sun was just clipping the fringe of yellowish grasses on top of the bridge, and the strong silvery light on the water brought the underside of the bridge into sharp relief.

It was quite a magical moment!

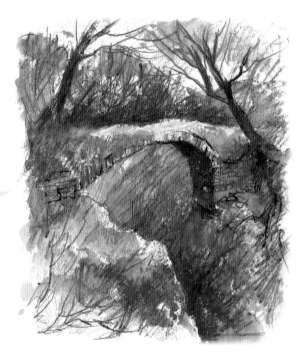

Back in my studio I played around with water-soluble coloured pencils, simplifying some of the elements and emphasizing others to give a more dramatic slant to the scene.

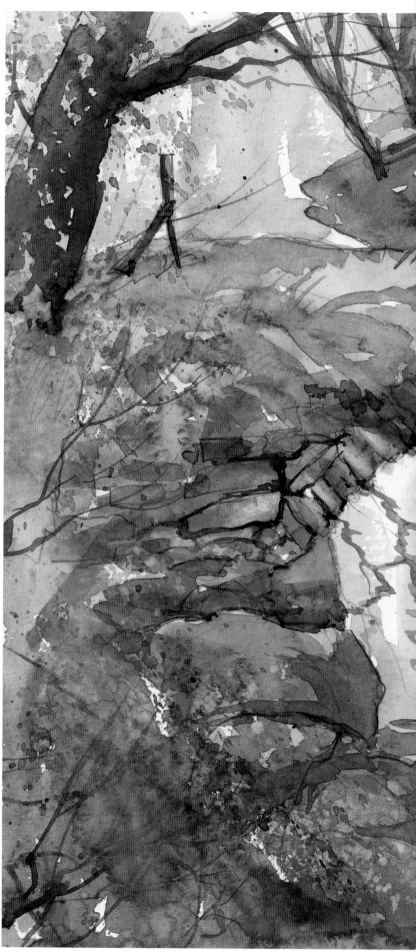

CATCHING THE LIGHT
43 x 33cm (17 x 13in)

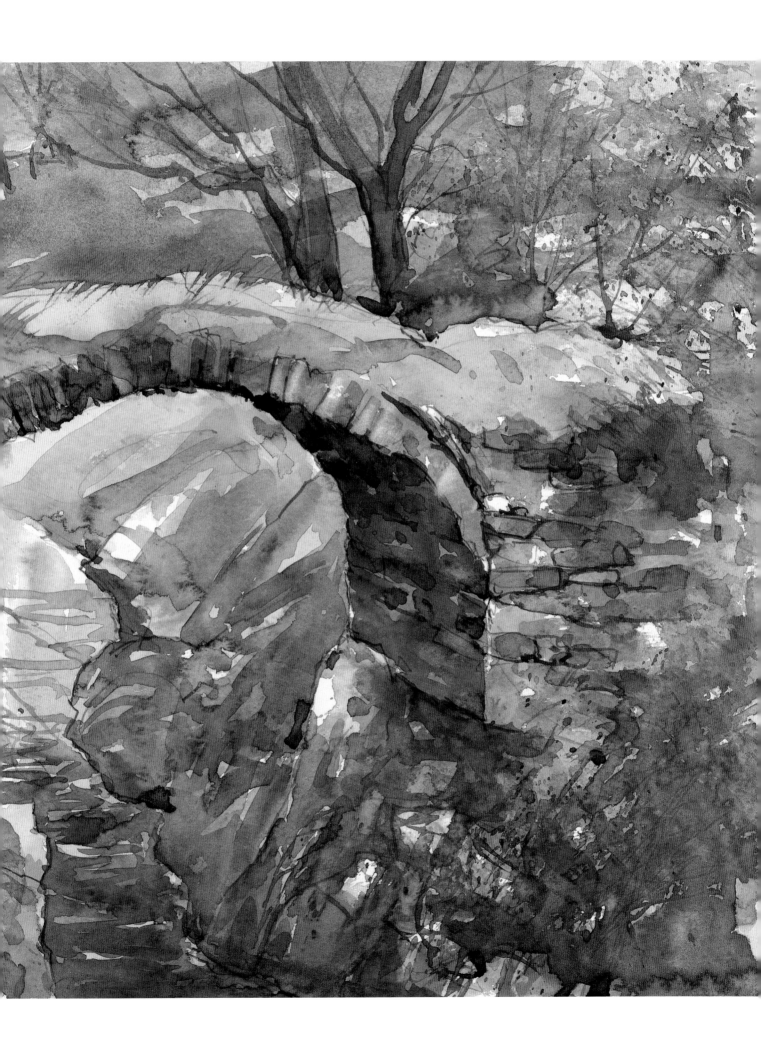

TECHNIQUES

There are many diverse and wonderful methods of making marks on paper and I am always experimenting with different ways of creating textures and patterns that will enhance a painting. However, do not let techniques take over! Techniques for techniques' sake will make a painting contrived and overdone, and the question asked will be, 'how did you do it', rather than 'why did you do it'. Techniques should only be used to enhance a painting and produce textures that cannot be accomplished by regular painting methods.

MASKING FLUID

This is a really great medium which enables you to do a wet into wet wash over the whole painting and still reserve your whites. But beware! If masking fluid is applied with a heavy hand – slopped on as if with a plasterer's trowel or squeezed out like toothpaste from a masking fluid pen – you could end up with something rather horrid. I apply masking fluid with an old brush, a twig, a piece of string or anything else that makes a delicate painterly mark and the result is better for it.

Be careful not to leave masking fluid on the painting too long. Get your initial washes down, then, as soon as they are dry, get the masking fluid off.An exception to this is Schmincke masking fluid, which is a different ball game altogether. The fluid does not have any ammonia in the content and so does not react with the paper as adversely as those with it. As a result, you can leave the masking fluid on the paper for longer without any ill effect. The shelf life is much longer than other brands, too, which is a nice bonus.

Take care when using a hairdryer to dry paintings with masking fluid on. The heat can make the masking fluid rubbery, causing it to smear when you try to remove it.

Masking fluid applied with an old brush.

Masking fluid spattered onto the paper, then moved around with a brush handle.

32

Using the technique

This tiny clapper bridge is just down the road from Dartmoor prison, UK, and it would have been very easy to miss it tucked away by the side of the road.

You will notice that I have used masking fluid in the foam areas of the stream using a rigger. I have also spattered some highlights as well. What might not be so obvious is the fact that I also masked the top edge of the capstones. This meant I could pull the dark paint right up to the bridge and still get a nice sharp edge.

CLAPPER BRIDGE, DARTMOOR
40 x 40cm (15¾ x 15¾in)

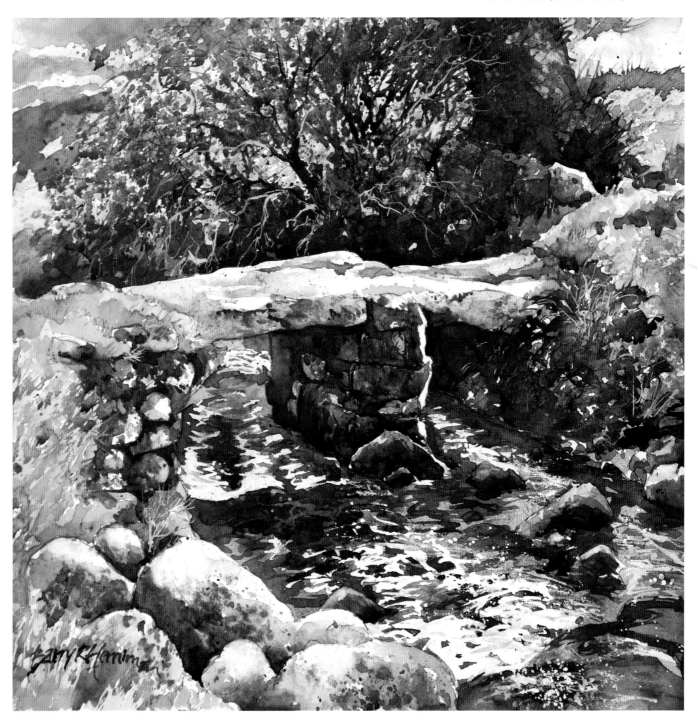

SCRATCHING OUT ON DRY PAINT

Use quick sideways movements of a craft knife to carefully scratch highlights out of dry paint. A great technique for those final sparkles across water, but note that it does damage the surface of the paper, and you will not be able to paint over it once done.

Highlights scraped out of dry paint with a scalpel.

SCRAPING OUT FROM WET PAINT

This is a great way to produce light tree trunks against dark backgrounds. The underlying paint must be just damp for this to work. Lightly scrape the side of a palette knife, fingernail or credit card (nothing with too sharp an edge) into the paint to produce your light marks. If the paint is still too wet, the mark that is left will be considerably darker – which is fine if you planned it that way!

Tree trunks scraped out of wet paint with the handle of a brush.

LIFTING OUT

You must let the paint dry for this technique to work, and you should use a brush that is slightly more abrasive than a watercolour brush (a hog or bristle brush is ideal). Wet the brush with clean water, gently rub the area to be lifted, then dab the wet marks with a clean piece of paper towel to lift the colour.

Highlight lifted out with a damp brush.

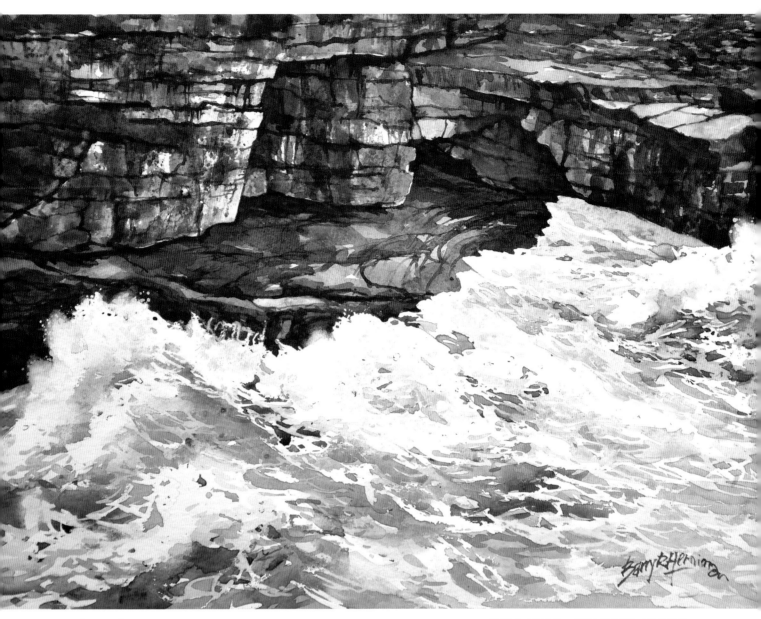

Using the techniques

Here, I have tried to capture the huge swell of the sea as it pushes its way to the cliffs. Even on a relatively calm day, you can feel the power of the sea (see *Atlantic Cauldron* on page 65 for a rougher example).

To capture all the breakers and foam trails I used quite a lot of masking fluid. I could then go into the sea with some lovely wet watercolours without fear of sullying the whites. Masking fluid marks always leave sharp edges, so with a bristle brush I softened some of the hard edges by lifting out the colour and dabbing it with a tissue. To get those extra textures in the cliffs I have scraped and scratched some small highlights into the paint – but note that I have not overdone this as the technique hurts the paper. There's no going back once done!

WILD FOAM, YESNERBY CLIFFS, ORKNEYS
38 x 28cm (15 x 11in)

DRY PAINT SPATTER LIFT

Another way of lifting out paint is to use the spatter technique. Flick a brush loaded with clean water over a dry passage of colour, leave for a while, then dab the wet marks with a clean paper towel. Alternatively, use a squirt bottle to apply a light spray of clean water over an area and lift out with a paper towel. These methods of lifting out create a really good random texture which is great for rocks and cliffs.

Marks made by lifting out colour after flicking a brush loaded with clean water on the dry paint.

36

Using the technique

On a trip to the lovely Achill Island in Ireland, we decided to climb up the rough mountain side to get a view of Croghaun, a 600m (2000ft) sea cliff that descended sheer into the sea. On the way we had to cross this stream which caught my eye with all the mixtures of colours in the gorse and grasses.

I have spattered a lot of water into the foliage and lifted out paint to get that random texture. I have then gone back in with wet paint to increase the texture.

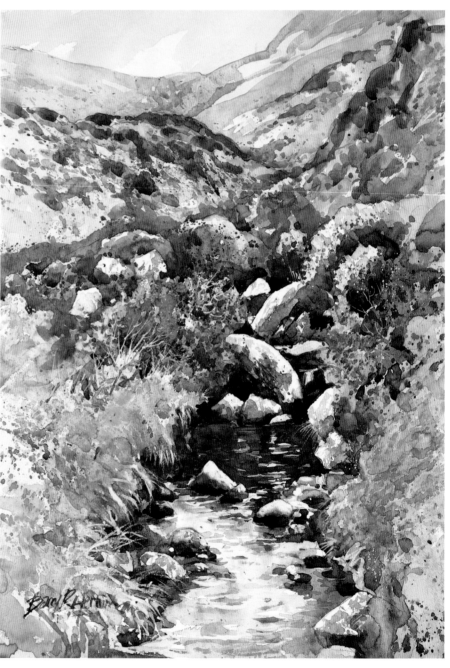

MOORLAND STREAM, ACHILL ISLAND
30 x 38cm (11 x 15in)

Using the technique

This striking area of the Lagos coastline, with all its bright vibrant colour and textures, is a real joy to paint. When I got to see the scenes in front of me, I was hooked – especially with the strong light that seemed to illuminate the scene.

This was a demo I did for an art society and I had a great time infusing the scene with bright, pure colours then lifting out and going back in with spattered paint to build up the textures. You will notice this in the rock areas.

Here I used my squirt bottle to spray water on the dry paint before lifting out colour.

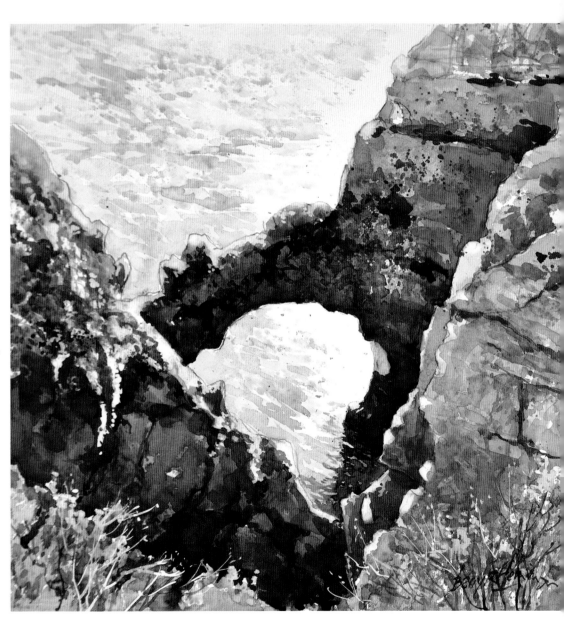

SEA ARCH, LAGOS COAST
31 x 31cm (12 x 12in)

BACKRUNS

The last thing you want in the middle of your lovely sky wash is a backrun or 'cauliflower'. But, in certain areas, you can use backruns for particular effects. Leave the wash until it starts to dry, then touch a brush loaded with colour on the spot where you want the backrun and see what happens. This is a rather unpredictable technique, so use it with care.

Backruns can be used to great effect.

Using the technique

On my painting holiday to the Grand Tetons, USA, we stayed just outside the small town of Driggs, Idaho. From here it was a short drive up into the foot hills where we got these super scenes of fall foliage and huge rocks. The scene was further enhanced by the fact that there had been a heavy ground frost which added a sparkle throughout.

To contrast the bright yellow-orange foliage I painted in the fir trees with juicy greens and browns, allowing them to merge with each other producing backruns in the process.

FIRST FROST, IDAHO
38 x 30cm (15 x 11in)

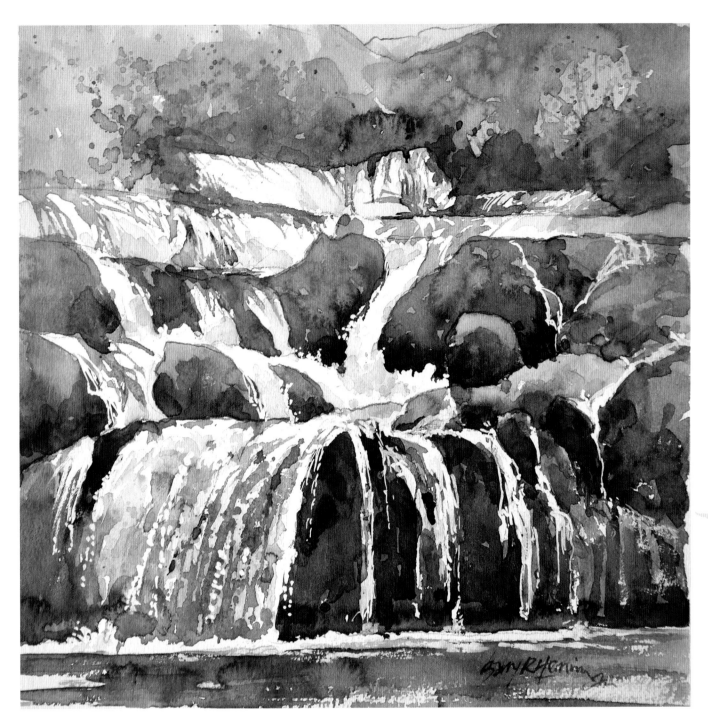

Using the technique

On one of my painting holiday cruises around the Croatian islands we made an excursion to Krka falls, which was fantastic. The area is made up of a succession of lakes and waterfalls that culminate in this tremendous series of falls. There really was 'water, water everywhere'!

Back on the boat I decided to paint up this series of falls whilst the experience was so fresh in my mind and couldn't wait to get something down on paper. After mixing up all my rock colours, I started to drop in some lovely rich colours. Before they dried completely, I went into them with more paint to produce backruns. If you study the painting, you'll see where they are. They are especially noticeable on the rocks, where they give the impression of lichen.

KRKA FALLS, CROATIA
30.5 x 30.5cm (11¾ x 11¾in)

DRY BRUSH

This technique works best on a rough paper that has plenty of tooth; it is perfect for speckled highlights on water. Load a brush with colour (not too wet, or it will flood into in the 'valleys' of the paper and you will lose the sparkle), then drag the side of the brush quickly across the paper catching the 'ridges' of the paper surface.

Speckled highlights created by dragging a brush (loaded with blue paint) across the surface of rough paper.

Using the technique

A rather 'soft' Scottish day, but with some strong accents of light around the small castle on the edge of the loch. The milky clouds were obscuring the hillside in places so I kept the whole painting low key to accentuate the mistiness.

This painting shows how a build-up of glazes can capture the transient light that was visible over the loch. Dry brushing was used to add some sparkle to the water's surface, providing some detail to contrast with the overall softness.

SCOTTISH SOLITUDE, ARGYLL
63 x 46.5cm (24¾ x 18¼in)

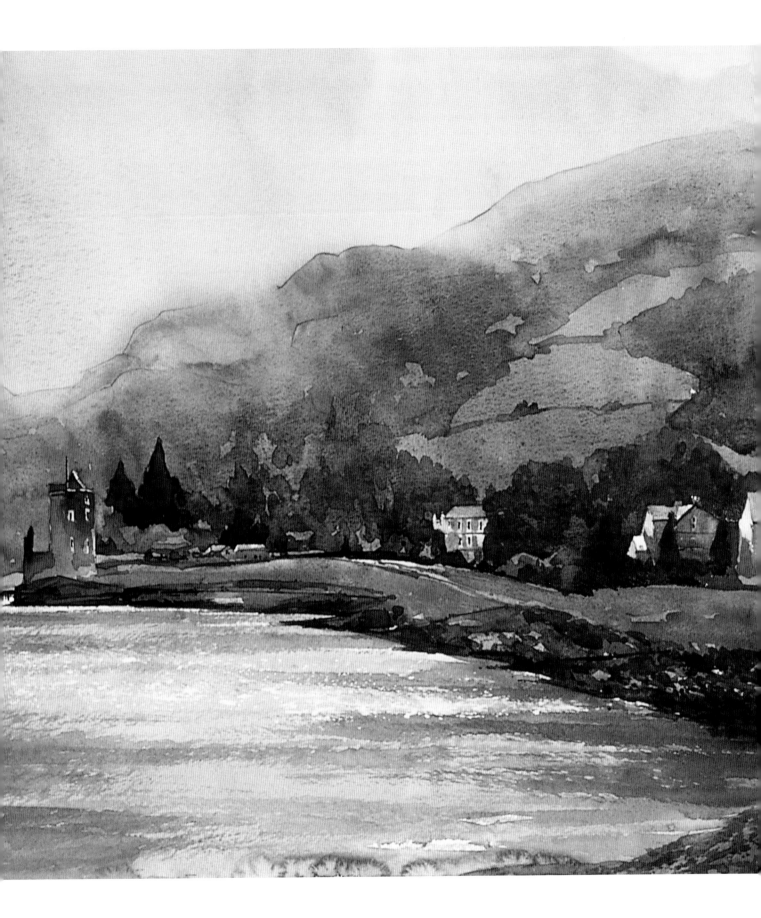

GOUACHE (OPAQUE WHITE)

Gouache is a good way of producing small, crisp, wispy highlights. It is, however, a very opaque white, so never put it in your palette of watercolours – even a touch of it can spoil the transparency of watercolour. Do not overdo the use of gouache; remember that it is opaque and you can very easily create a very dull passage of colour.

Unlike watercolours, which tend to dry lighter than the colours appears when wet, gouache dries darker – and the more you dilute it the darker it becomes. If you want a really white highlight, you will have to use almost neat white gouache. Even so, white created by gouache will never be as bright or white as the paper.

Here, I used gouache to brush in some water rivulets over the rocks, then flicked on more paint to form the spray.

Using the technique

The lovely cascades in the sketchbook below and painting opposite were halfway up a mountainside in Turkey. We happened on them almost by accident and were so taken with the area we stayed the whole afternoon. Both illustrate the use of gouache to produce highlights within waterfalls.

As I never use masking when painting in my sketchbook *en plein air* I have to rely heavily on reserving my whites and then using gouache to add the final sparkles. I have to be very aware of where I want pristine white paper as there is no substitute for the crispness and sparkle it produces.

The studio painting of the same area differs only in the fact that I was able to use masking fluid with the initial washes, thus guaranteeing the whites. Once I had all the

initial washes in place, I removed all the masking fluid and softened some of the hard edges that are an inevitable result of using masking (keep this in mind when using it as, depending on your subject, you may need to do some 'rewriting'). I used a stiff bristle brush to gently lift out the paint with clean water, then blotted the area with a tissue. This gives the soft edge where the water is flowing over the rocks. Then to add the finishing touches, I flick in some pure white gouache for the spray around the rocks and the foreground water.

SKETCHBOOK PAINTING: KESME BOGASI, TURKEY
25 x 56cm (10 x 22in)

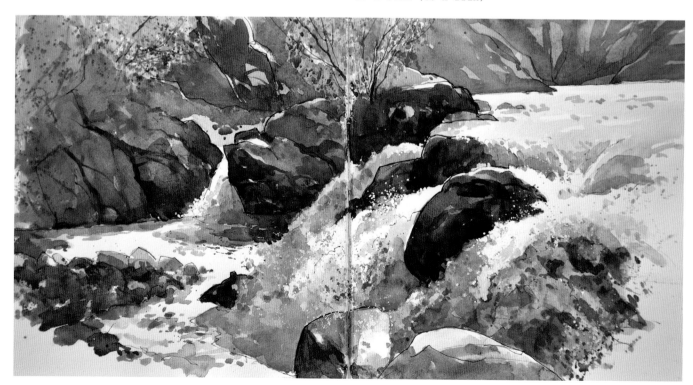

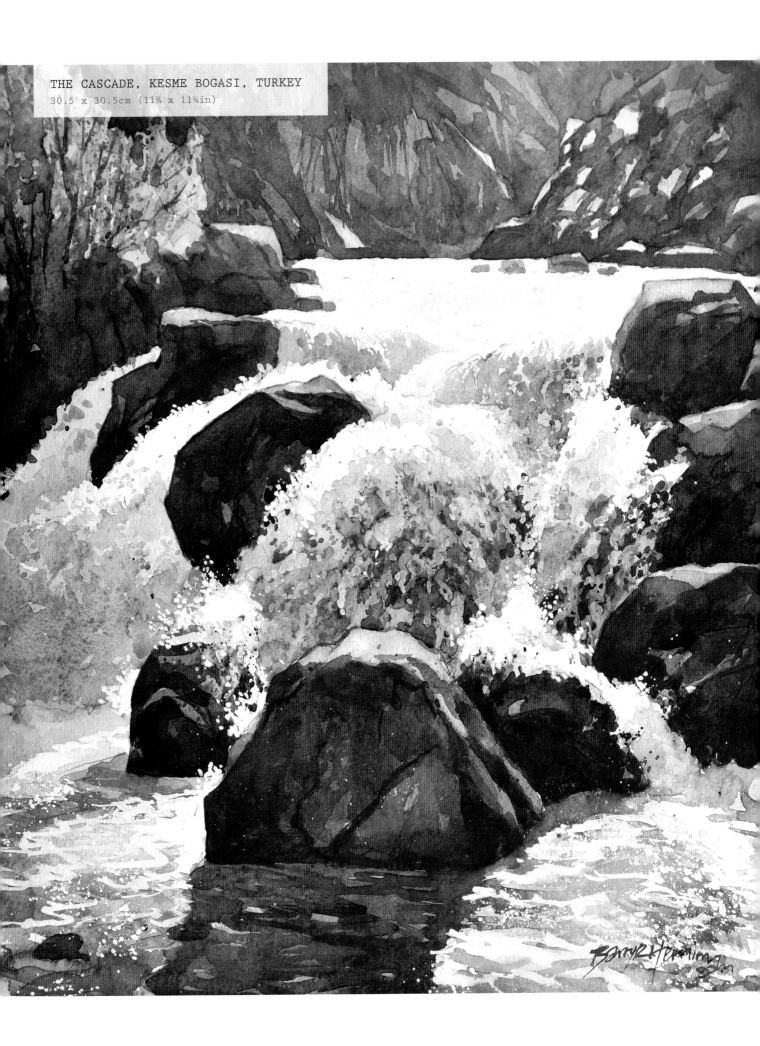

SPATTERING

Having lived in the Forest of Dean for many years I had a wealth of woodland scenes right on my doorstep, so when I started painting I was drawn towards these locations. The next hurdle was how to capture the shifting light and shade within the foliage without it becoming rather stilted and lacklustre. I started by using a toothbrush to get the required spatter but this was altogether too haphazard and I needed to mask out large areas which wasn't too much of a problem in the studio. Once out in the field this process was totally unsuitable for purpose so I looked at an alternative.

That is when I started flicking paint from a loaded paintbrush. It soon became apparent that I could flick paint into a confined space without it flying out of control all over the painting. That is when one of my students told me 'You should be called Herr Flick,' and the name has stuck!

Using the technique

This technique can be done in any number of ways and combinations. In the example at the top of the page, I loaded a brush with yellow paint, then flicked the point diagonally across the paper. While that was wet I introduced some blue. Half the paper was dry and the other half had water on it – notice how the paint diffused nicely on the wet side.

The painting here is the view looking upstream of East Lyn River in Exmoor, UK. The light was just catching the water through all the dense foliage lighting up the whole scene.

To ensure that I preserved that wonderful light I masked out all the highlights so that I could flood in glorious wet watercolour knowing they would be retained. I could now literally throw paint at the scene, building up the strength of colour in the foliage with a series of spattering movements.

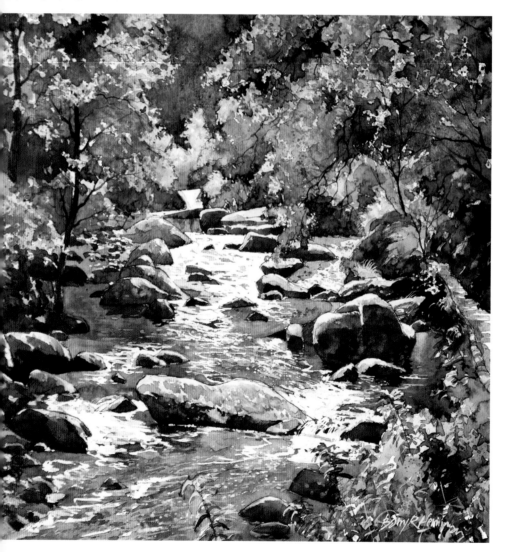

WATERSMEET IDYLL, EXMOOR
40 x 40cm (15¾ x 15¾in)

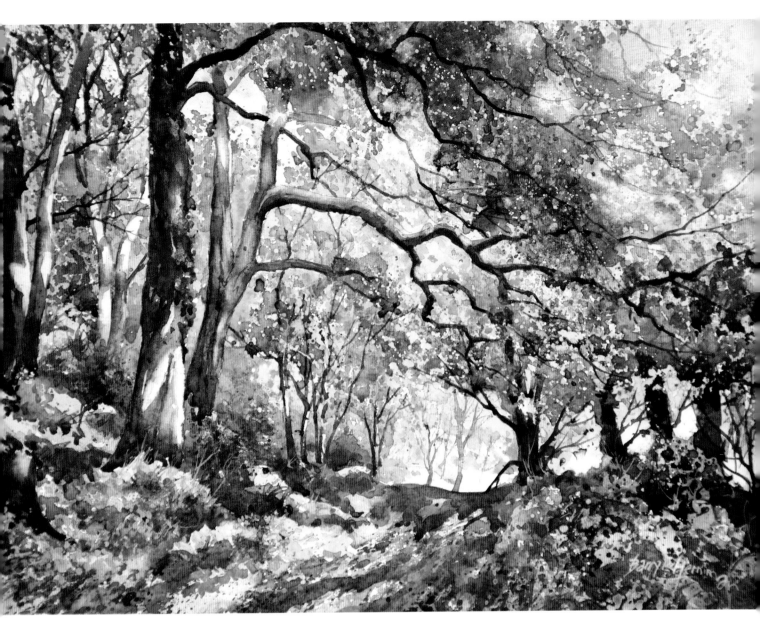

This painting, of Cranham woods in early autumn, shows my spattering technique in full flow. The leaves were just on the turn so the red-orange colours were interspersed with shades of green which produced a striking mosaic. I had a great time watching all the flicked paint mingling and merging on the paper before my very eyes as I left the watercolours to almost do their own thing. A very satisfying way to capture transient light in foliage, so give it a try and you'll see what I mean.

CRANHAM MOSAIC
56 x 38cm (22 x 15in)

COMBINING THE TECHNIQUES

I have chosen these two paintings to illustrate how the techniques on the preceding pages can come together to produce vibrant and pleasing works. It is very easy to overdo the technique side of things and the painting can become over-fussy and fractured, so please use them sparingly.

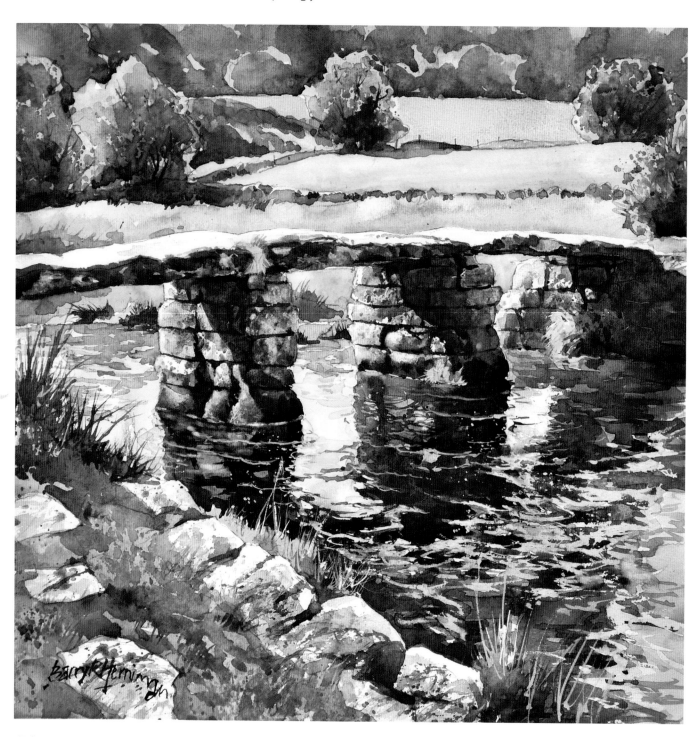

CLAPPER BRIDGE, POSTBRIDGE, DARTMOOR
40 x 40cm (15¾ x 15¾in)

I caught this view of this well-known clapper bridge at Postbridge on Dartmoor after crossing it to the opposite side where I could capture the shadows in the bridge and the water. I have used masking in the water and also along the top edge of the capstones. With the mask in the water, I was able to establish all the dark shadows in one go. The quiet washes in the background contrast nicely with all the textures in the foreground.

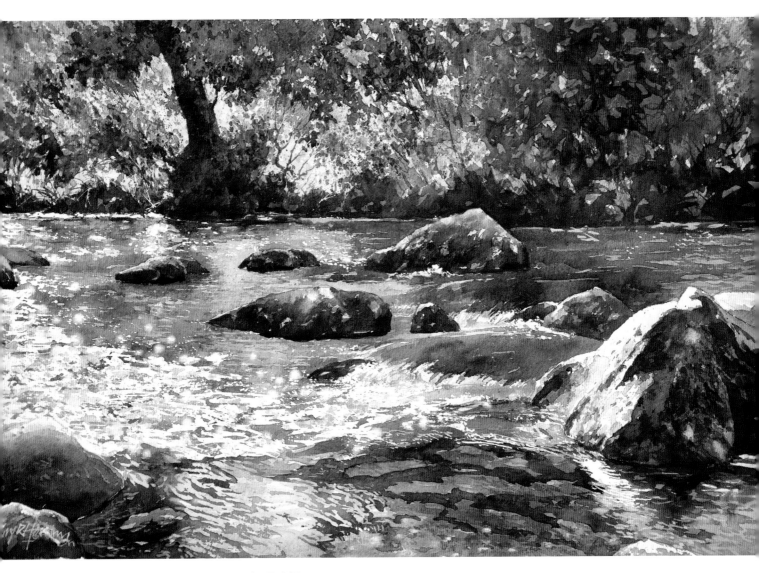

SUNLIT WATERS, RIVER DART, DARTMOOR

56 x 38cm (22 x 15in)

I went to town on this painting as there were a myriad textures and colours within the scene. The trees on the river bank had sunlight filtering through them so I spattered and lifted paint in all directions to produce that lovely randomness in the foliage. With the river I have gone for a much quieter approach. I masked out the highlights on the water, then laid in some large wet washes letting the different colours merge gently into each other. You'll also notice the different textures in the rocks.

USING A SKETCHBOOK

I find there is nothing more stimulating than painting *en plein air* in front of your chosen subject, and I have filled sketchbooks with paintings of some wonderful venues both home and abroad. When I first started, my forays into sketching were very limited. I always wanted to produce watercolour sketches that would capture the moment and remain fresh and vibrant, but painting watercolour on the cartridge paper that most sketchbooks contained always tended to mute the colours, leading to unsatisfying results. However, once I sourced some wonderful hardbound sketchbooks that contained watercolour paper, my sketching really took off.

My sketchbooks contain smooth hot-pressed (HP) paper which is great for pen work as the tip just glides over the surface. As I love drawing, I tend to use the line and wash technique exclusively – that is, drawing with a waterproof pen, then using watercolours to overlay a wash into the lines. If time is of the essence, a half-finished sketch can be as satisfying as a full-blown painting. I use waterproof felt tip pens which give me a nice sharp line and then add the watercolour washes to the drawing.

Painting outside, with all the vagaries of the weather, has sharpened up my painting style and stopped me getting too fiddly. These pages show just a few of my sketchbook paintings.

Over the years, what with the ever-diminishing baggage allowance on airlines, I have had to pare down my painting kit to the bare minimum. This isn't such a bad thing. I have seen students lugging around everything – and the kitchen sink – but you really don't need the hassle.

Pictured here is my basic travelling sketching kit, which consists of sketchbook, my Cloverleaf Paintbox, a selection of round brushes and brush tube, felt tip pens, propelling pencil, spray diffuser bottle and water pot. Not shown are my folding easel and lightweight board. That's all you need!

I include notes along with my sketches. These help inform my painting back in the studio.

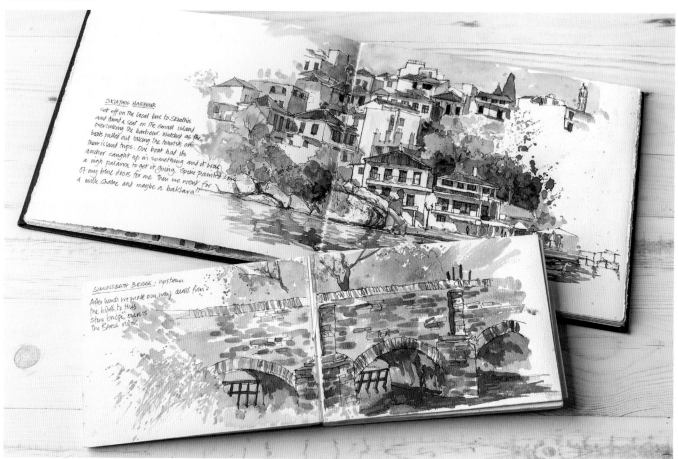

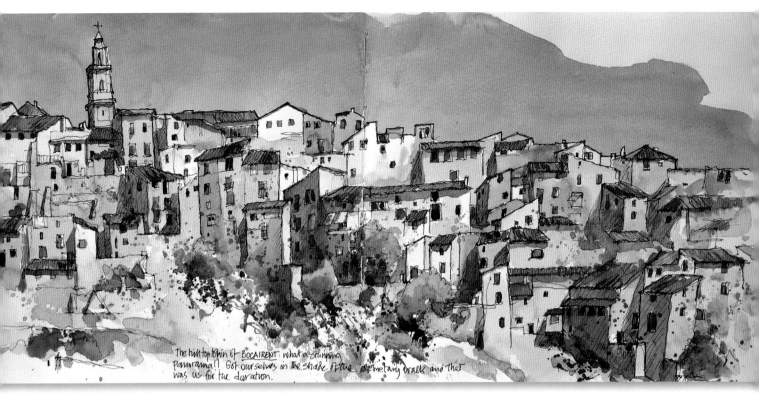

The hilltop town of BOCAIRENT. What a stunning panorama!! Got ourselves in the shade of the cemetary walls and that was us for the duration.

A selection of my sketches.

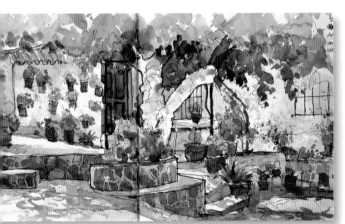

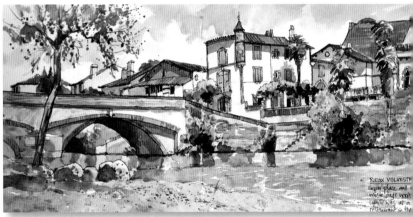

RIEUX VOLVESTE
Super place and whole days kept...
Lunch was at a restaurant in the...

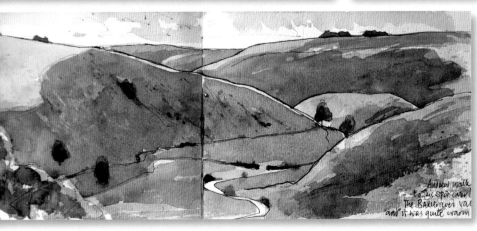

Andrew walk to this spot over the BARU river val... and it was quite warm

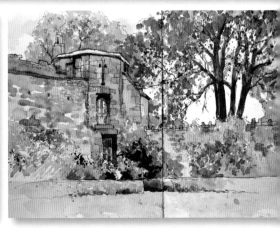

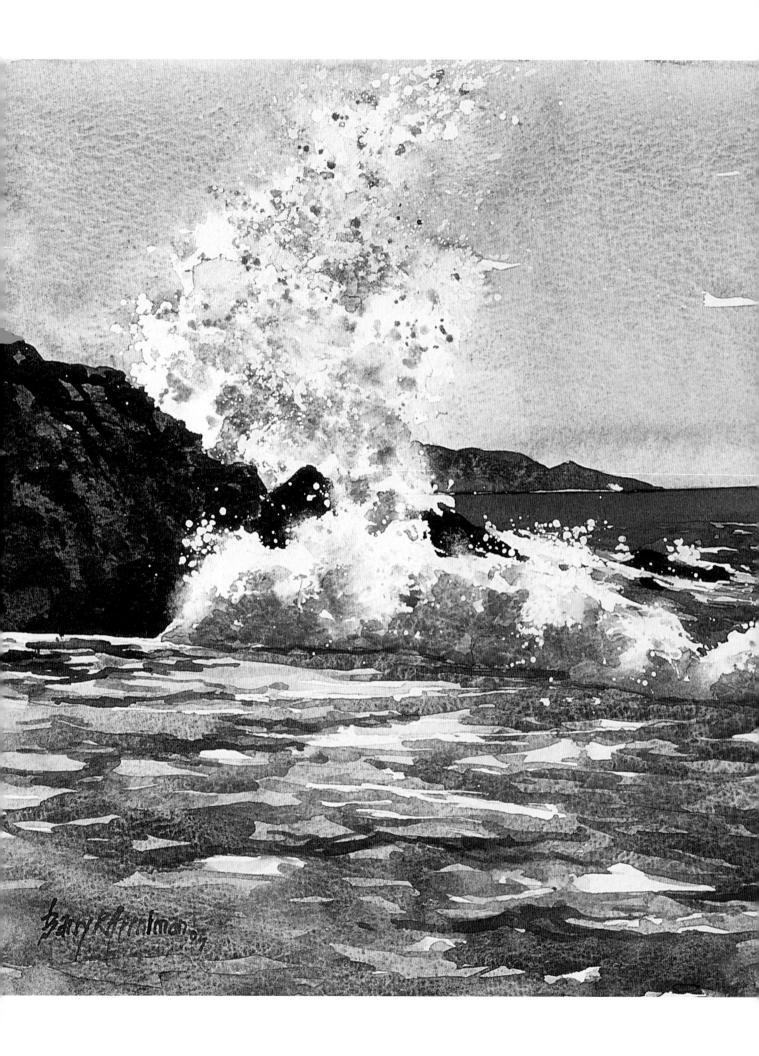

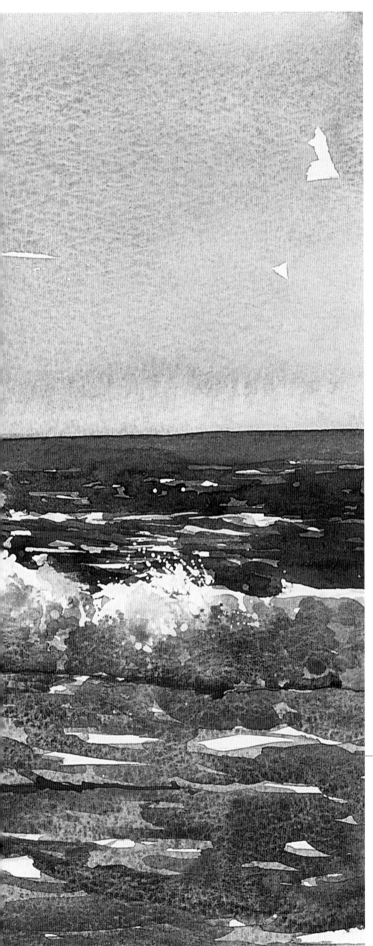

Breaking Waves

I love the sea and all its moods, so I just had to start the step-by-step demonstrations with a seascape. I have such an affinity with water whether it is the sea, rivers, streams, lakes or ponds, that I feel that I should have been born under Aquarius. Water, in some form or other, seems to find its way into most of my paintings, even if it is only a puddle! I can spend hours just looking at the sea, watching the patterns that emerge, then disappear; all quite mesmerizing. Because of the fluidity of water I am able to give vent to my artistic temperament. I am not restrained by architectural detail and I can 'splash' around quite freely.

What I wanted to convey here was the simplicity of a scene with a rather dramatic, crashing wave. On this particular morning the wind was quite strong and, although the sea was not overly rough, it created a deep swell and some hefty breakers on the rocks. This gave me the chance to lay in some gentle, gradated washes for the sky and some loose, flowing ones for the sea.

The photograph and tonal sketch on the following page were used as the reference material for the demonstration. Quick tonal sketches (this was worked upon cream paper using water-soluble pencils) are useful for defining the lights, darks and mid tones in the composition.

You will need:

Watercolour paper, Not surface, 640gsm (300lb), 40 x 30cm (15¾ x 11¾in)

Watercolours: aureolin, Indian yellow, cobalt blue, French ultramarine, manganese blue, phthalo blue, alizarin crimson, Winsor red, manganese violet, brown madder, burnt sienna

White gouache

Masking fluid and an old brush 2B pencil

Brushes: Nos. 10 and 16 rounds; No. 3 rigger

Bristle brush

Paper towel

Water sprayer

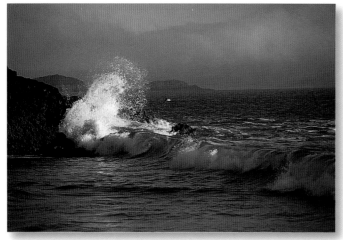

The photograph and tonal sketch above were used as the reference material for the demonstration.

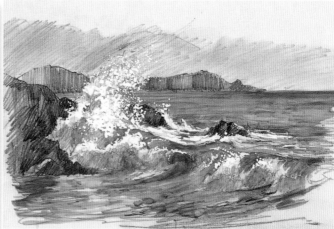

Quick tonal sketches like this – worked upon cream paper using water-soluble pencils – are useful for defining the lights, darks and mid tones in the composition.

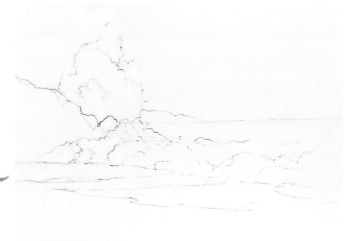

1 Use the reference material to draw the outlines of the composition onto the watercolour paper. Do not make the pencil marks too faint, or you will not be able to see them when the first washes have been applied.

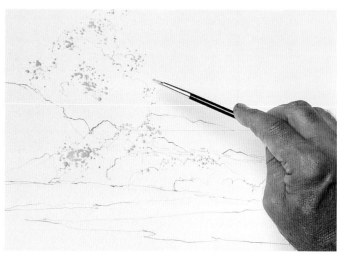

2 Use masking fluid and an old brush to spatter highlights in the spray from the wave crashing against the rocks. Work carefully, changing the angle of the brush with the direction of the spray.

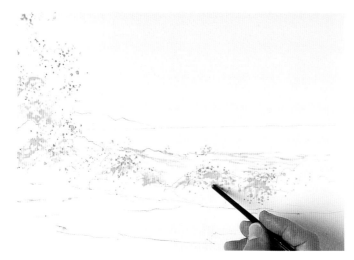

3 While wet, use the handle of the brush to blend some of the spatters together to form nearly solid areas.

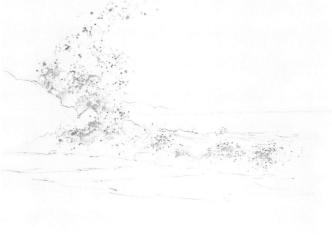

The paper with all the masking fluid applied.

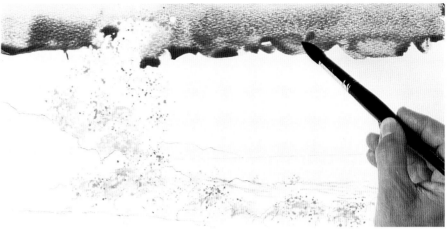

4 Using a palette with large deep wells, prepare the initial washes: cobalt blue, Winsor red, Indian yellow and manganese blue (see left). Spatter clean water round the big wave (to stop hard edges forming), then use the No. 16 brush to lay in a band of cobalt blue.

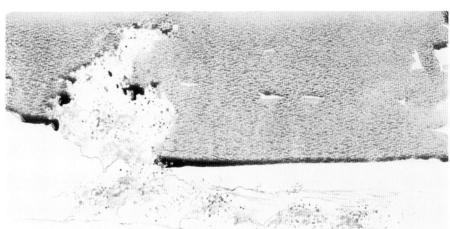

5 Add some Winsor red (see left), then blend this into the blue. Spread the colours down towards the horizon, blending in touches of Indian yellow in the lower sky. Allow a bead of colour to form on the horizon line.

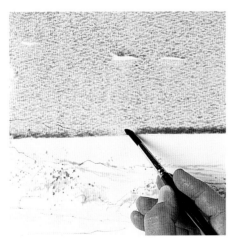

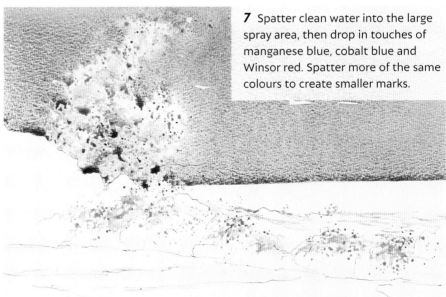

7 Spatter clean water into the large spray area, then drop in touches of manganese blue, cobalt blue and Winsor red. Spatter more of the same colours to create smaller marks.

6 Leave the wet bead of colour to form a hard edge, then use a dry brush to remove the excess water.

8 Add the sea colours – phthalo blue, aureolin, alizarin crimson and French ultramarine – to the palette, then work on the area of sea behind the waves, wet on dry. Lay a band of cobalt blue along the horizon, followed by a band of phthalo blue. Add touches of alizarin crimson and aureolin. Dipping the brush into various colours, make the brush strokes looser and the saved whites bigger as you work down the paper. Turn the painting upside down to create a strong edge on the horizon and leave to dry.

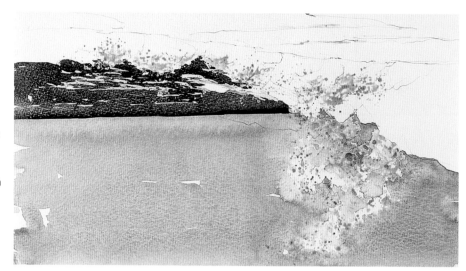

9 Use weak washes of manganese blue and alizarin crimson to lay in the pale area of sea below the large breaking wave at the left-hand side. Develop the remaining part of the foreground with loose brush strokes of cobalt blue, Indian yellow, alizarin crimson and aureolin. Push, press and pull the brush on each stroke to create the small wave shapes. Again, make the saved whites bigger as you work down the paper.

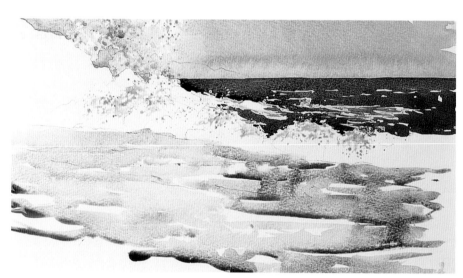

10 Angle the painting board up at the left, then drop in more cobalt blue, Indian yellow and alizarin crimson, wet in wet, and allow these to run across the paper. Lift the other side of the board to make the colours flow back across the paper, then leave to dry with the top edge raised slightly; the hard edges that form create shadowed areas among the waves.

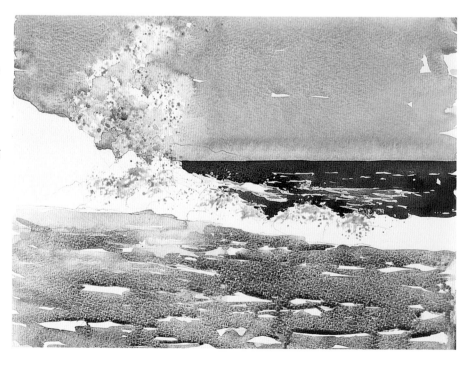

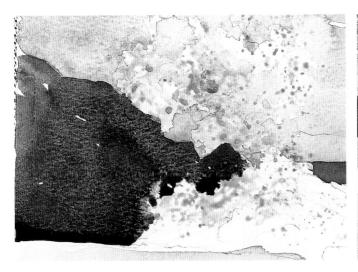

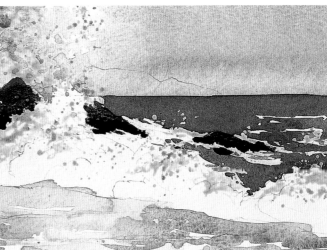

11 Spatter clean water over the left-hand side of the large spray area, then start painting at the left-hand side of the paper. Using rock colours – brown madder, burnt sienna and French ultramarine – block in a base coat of colour for the rocks, then drop in touches of alizarin crimson and Indian yellow here and there.

12 Use the same colours to paint the rocks at the right-hand side of the wave. (There is a lot of masking fluid in this area, so you can still use bold brush strokes.)

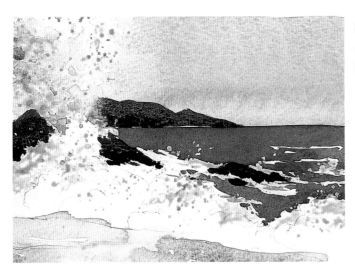

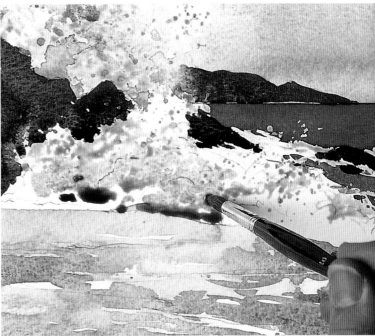

13 Wet the left-hand edge of the distant mountain, then use weak washes of the same colours with a touch of cobalt blue to paint the mountains. Leave a thin white line between the mountains and sea to suggest breaking waves.

14 Now work up the shadows on the breaking waves with cobalt blue, alizarin crimson and a touch of manganese blue. Holding the brush nearly vertical, trickle the colours into the bottom area of the wave. Work the colours between each other, then allow them to blend. Allow beads to form to create sharp edges at the bottom of the wave.

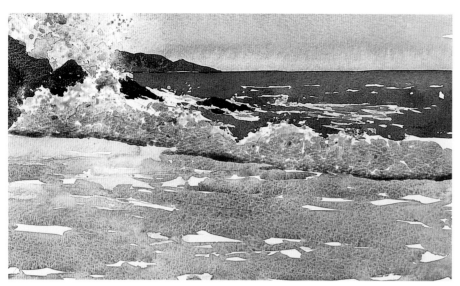

15 Continue building up the shadows across to the right-hand side. Use a dry brush to remove some of the excess wash colours from the bottom of the wave. Leave others to create hard edges. Leave to dry completely.

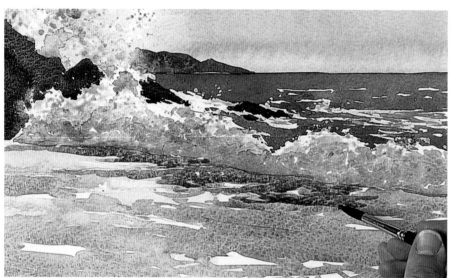

16 Dipping into the sea colours – cobalt blue, French ultramarine, manganese blue, alizarin crimson and manganese violet, and working wet on dry with a near-vertical No. 10 brush and a trickling action – start to strengthen the colours in the foreground. Vary the angle of the brush strokes to suggest movement in the water.

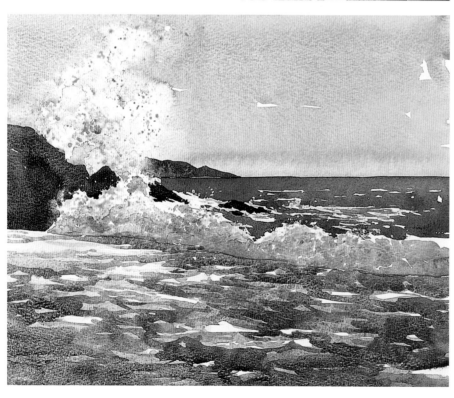

17 Continue building up the foreground leaving some of the saved whites from the initial layer of colour. Push, press and pull the brush to create the wavelet shapes. Apply a weaker wash over the nearest part of the foreground.

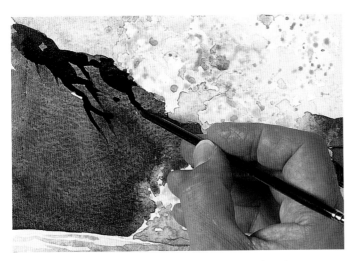

18 Dipping into the rock colours with a No. 10 brush, start adding colour along the top edge of the rocks, then use the handle of the brush to pull the colour down to form fissures.

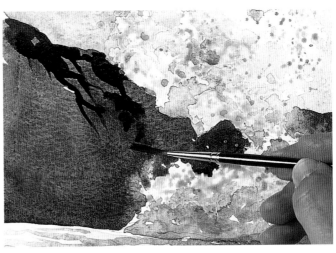

19 Create shadows on the rocks with a rigger brush. Load the brush by dipping into the rock colours, flatten it on the paper, then drag it sideways and downwards across the rocks.

20 Spatter darks over the rocks, then spray a fine mist of water over the wet paint to soften some of the hard edges of the fissures. Leave to dry, allowing the shape and structure of the rocks to develop on their own.

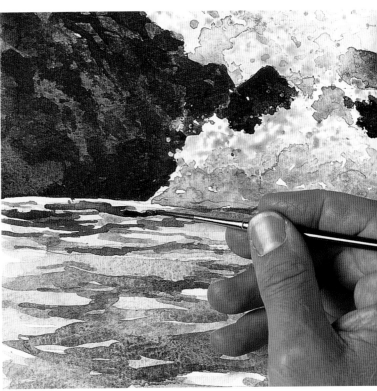

21 Use weaker tones of the rock colours to develop broken reflections of the rocks in the water. Push, press and pull strokes of the rigger brush to reflect the shapes of the wavelets.

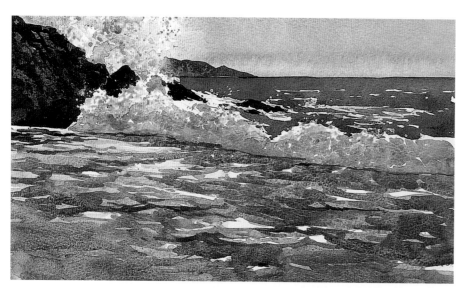

22 Working with the shapes already on the paper, use darker tones of the sea blues in the palette to accentuate them and create shadows against the highlights.

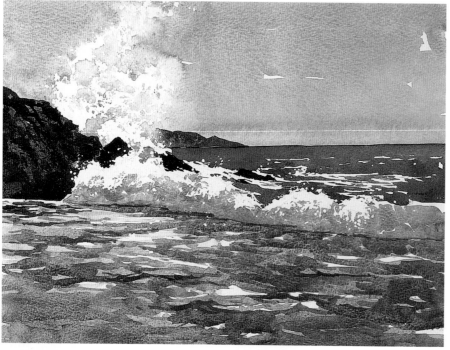

23 When the painting is completely dry, remove all masking fluid (I use an old piece of dried masking fluid as a 'lifter'). Run your fingers all over the surface to check for small areas you might have missed. We now have to go into these stark white areas and soften some of the hard edges – see the three steps below.

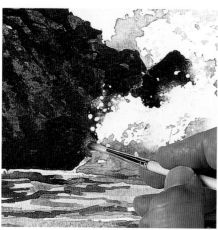

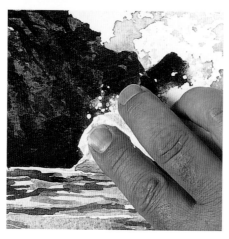

24 Now go into the exposed, stark white areas and soften some of the hard edges. Use a bristle brush to wet the edges of colour where the spray falls on the rocks.

25 Use clean paper towel to dab the wetted area.

26 Lift the paper away to reveal the softened edges.

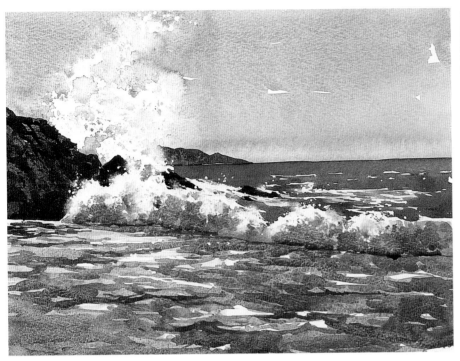

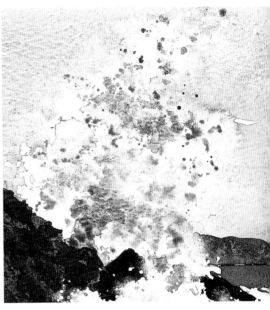

27 Work the same technique to soften the top edges of the waves in the middle distance and some of the edges of the shadows in the larger breaker and in the area of spray. Spatter water in the shadowed area of the breaker then trickle accents of darker tones of the sea blues to develop shape and form. Spatter small spots of colour into the waves, then soften all edges with clean water.

28 Develop the colours in the large spray area by spattering some darks followed by water to soften the edges.

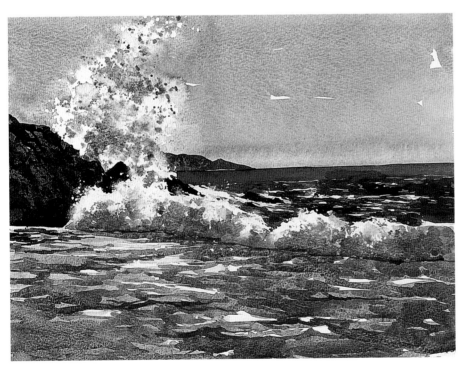

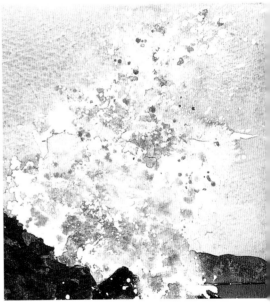

29 Develop the middle distant area of sea with phthalo blue and touches of alizarin crimson and Indian yellow. Cover some of the saved whites but leave others. Wash a mix of these colours across the far distant sea.

30 Complete the spray area by spattering touches of white gouache over the top part of it, then develop the fine spray along the top of the breaking waves. Vary the angle of the brush as you spatter.

The finished painting can be seen on pages 50–51.

CAPTURING CHAOS

The sea has many moods. Depending on the prevailing weather conditions, the scene you are confronted with can be rather chaotic. If you have time to stop and sketch the scene, that's great; but if not, this is where photography can help. When painting from photographs try not to copy them slavishly. Rather expand your own artistic slant to the scene adding and subtracting elements you like or dislike and including your own colour mixes.

On the day I painted *After the Wave, Donegal*, the sea did not look overly rough. However, there were some deep swells which produced some fairly spectacular spray where the sea met the rocks. I was in danger of being engulfed by a couple of them. The painting shows the aftermath of one such wave, which left behind a welter of white foam and spray as the sea slid down between the rocks.

I wanted to capture the chaos of the water as it bubbled over the rocks. I masked out some areas of foam and flicked and spattered white gouache on others to get this random effect. To get the strength of colour into the rocks I laid down a series of watercolour washes, glazing one transparent wash over another. You can see in the right-hand rocks where I have left the original bluish wash to shine through the dark overlying wash. There are also areas where I have lifted colours from the wash to produce more textures.

Orkney Foam Trails (see right) was another attempt to capture the vibrancy of chaotic foam trails around rocks. As with *After the Wave, Donegal*, I masked out the main foam trails beforehand to ensure I didn't sully these pristine white areas. The swell of the incoming tide produced these magnificent foam trails around the rocks. Notice that I spattered some colours into the foreground rocks and lifted out colour from the large left-hand rock. To finish off I added some white gouache to describe the rivulets of water over the rocks.

60

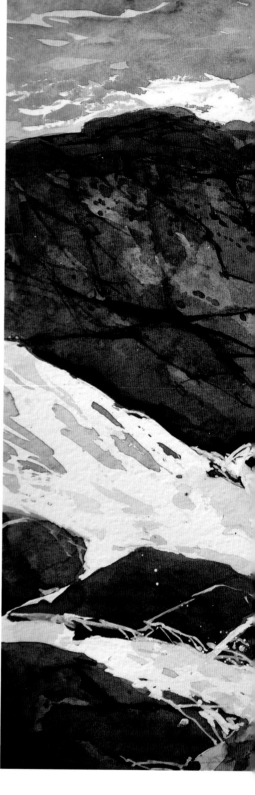

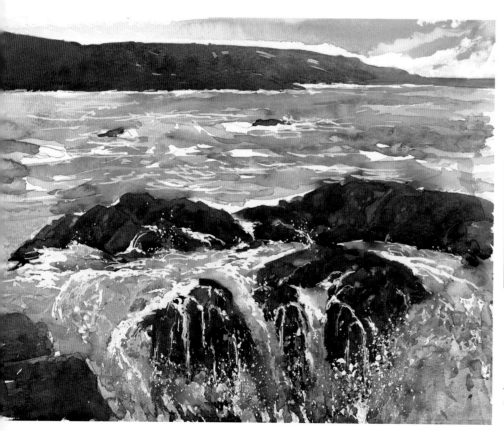

AFTER THE WAVE, DONEGAL
46 x 35cm (18 x 13¾in)

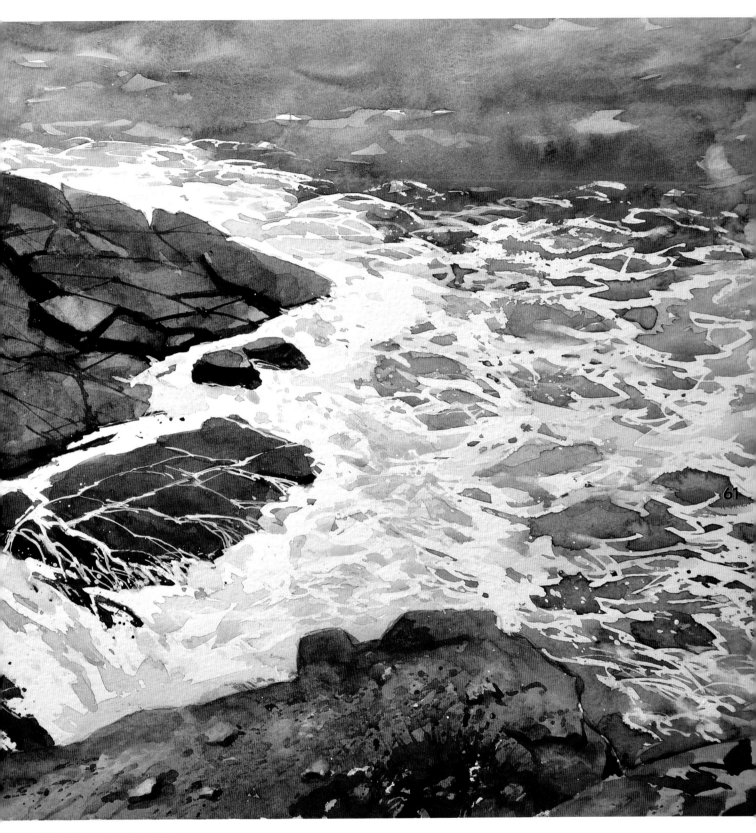

61

ORKNEY FOAM TRAILS
38 x 28cm (15 x 11in)

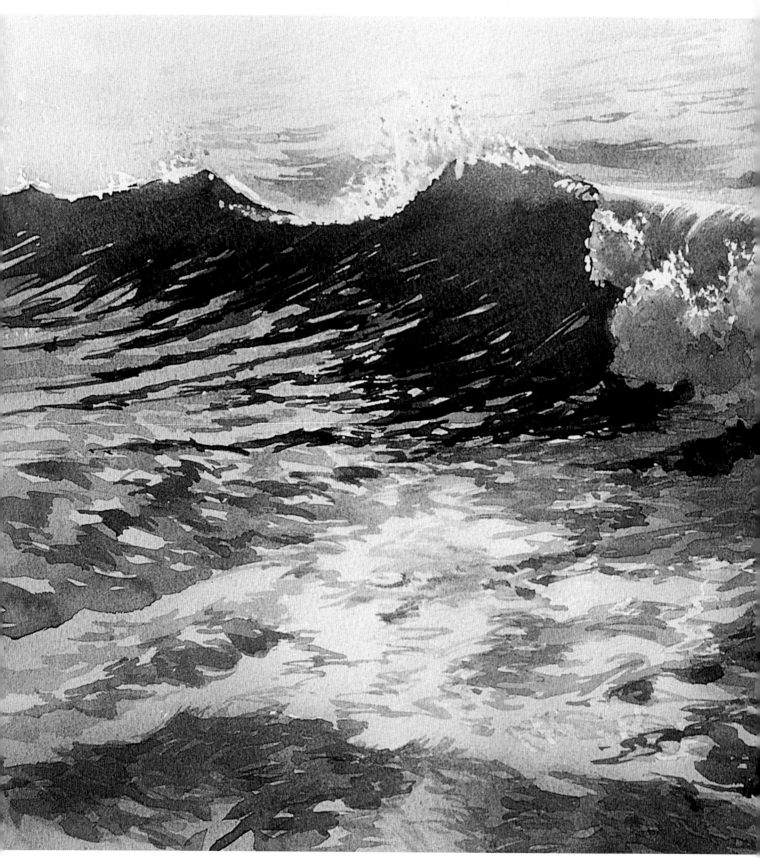

CLASSIC WAVE
50 x 35.5cm (19¾ x 14in)

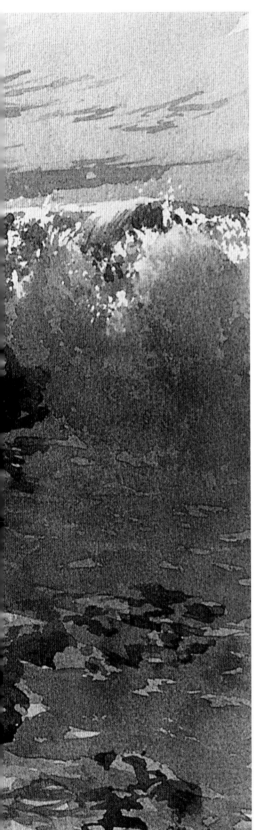

SIMPLICITY AND IMPACT

Simplicity in a scene does not necessarily mean just a simple painting – that could be boring. Rather, it means that the result is uncomplicated, not fussy, and avoids lots of conflicting elements. I think you will agree that although the two paintings shown here have a feeling of simplicity, they are not short on impact. Concentrating on the mood of a scene can be as important as the vista itself and in many cases more so.

Classic Wave is a simple painting of a wave catching the late afternoon sun. The slow lap of the wave as it broke on itself was quite mesmerizing; the crest almost translucent as the sun shone through the thin veil of water. Before I started to paint this picture I masked out both the wave highlights and the shadow areas, as I didn't want any of the green-blue wash encroaching into those areas. Once I had laid in the main wave colours I let them dry before removing all the masking fluid. I then went into these areas to drop in shadows, taking care not to get colour into the highlights. Last but not least, I flicked a little white gouache into the tops of the breaking wave.

The small painting below, *Last Light, Caldey Island*, was done in response to a rather quiet scene that would soon kick up rough. There was a slight sense of foreboding so I used dark colours to amplify this feeling. The bit that captivated me was the strong light on the horizon which was amplified across the water and over the breakers in the foreground. The breakers were masked out so I could lay down some lovely loose washes over the sea areas and know my whites would be retained. The sky is a nice example of wet in wet, the darks enhancing the strong light.

63

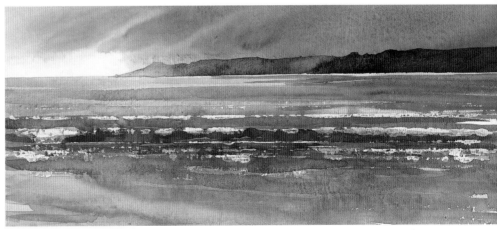

LAST LIGHT, CALDEY ISLAND
49 x 18.5cm (19¼ x 7¼in)

USING LIGHT IN YOUR SEASCAPES

We are now back to the most important and essential element in painting: light! Whether soft and diffused or sharp and defined, light is what determines the mood of any scene – and this is never more clear than in seascapes.

Break in the Clouds, Tenby shows a moment just before the sun appeared and lit up the whole scene. There was a strong glow around the edge of the clouds, suggesting that the sun was on its way. I have accentuated the billowing action of the cloud forms to get a lot of movement into the scene. I masked out the strikingly bright light at the edge of the clouds and dropped in all the lovely colours around them. I built up the strength in the clouds, some areas wet on dry and others wet on wet. This way I was able to get a nice transition between soft and hard edges.

As for *Atlantic Cauldron, Yesnaby cliffs, Orkneys*, opposite – talk about wild water! The strength of the sea colliding with the cliffs sent a shiver through them which went right through me. The late afternoon sun shining through the spray gave the scene a beautiful and somewhat ethereal feel. I masked out some of the foam patterns in the foreground but left the whites in the spray areas. Notice how the light bouncing off the foam in the foreground lights up the underside of the cliff, which would normally be in shadow. There is also very strong counterchange between the cliff edge and the rising spray.

Opposite:
ATLANTIC CAULDRON, YESNABY
CLIFFS, ORKNEYS
46 x 60cm (18 x 23½in)

BREAK IN THE CLOUDS, TENBY
46 x 32cm (18 x 12½in)

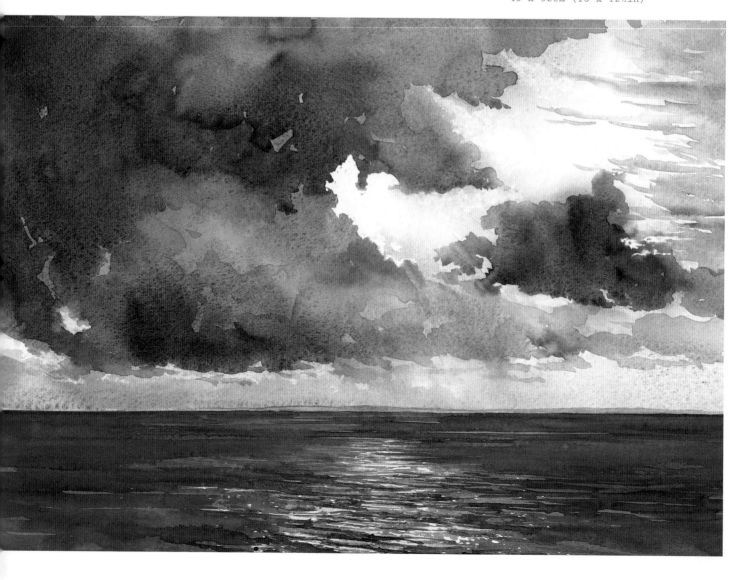

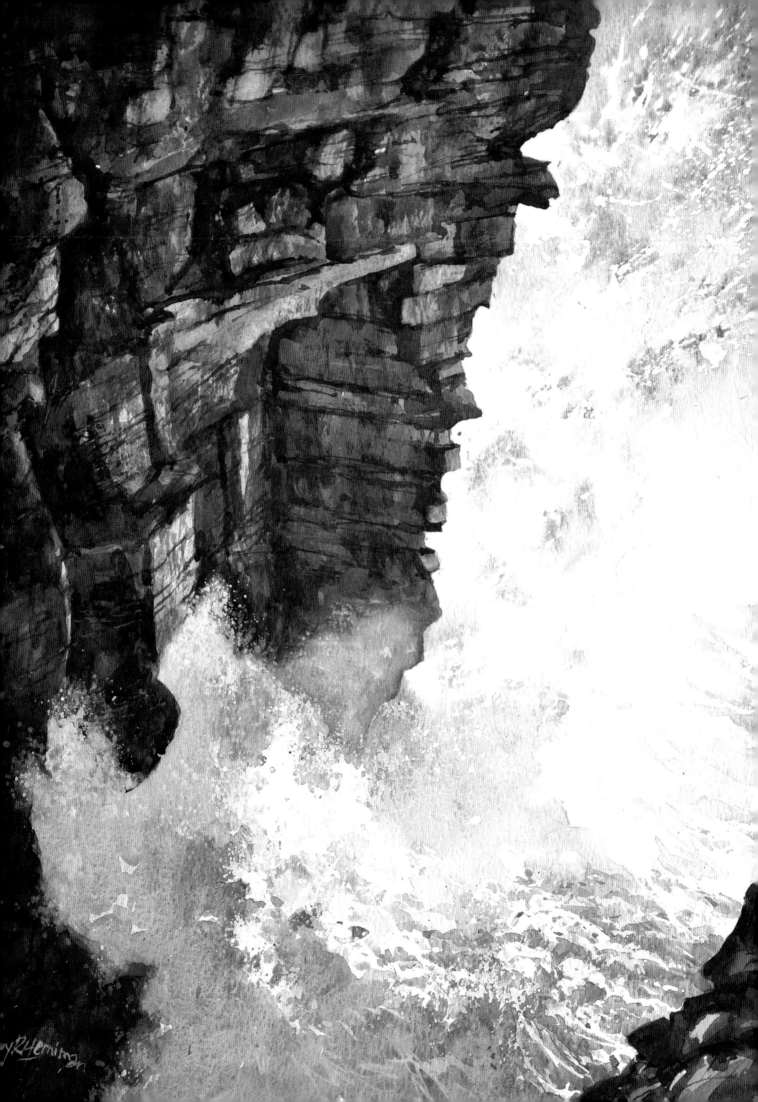

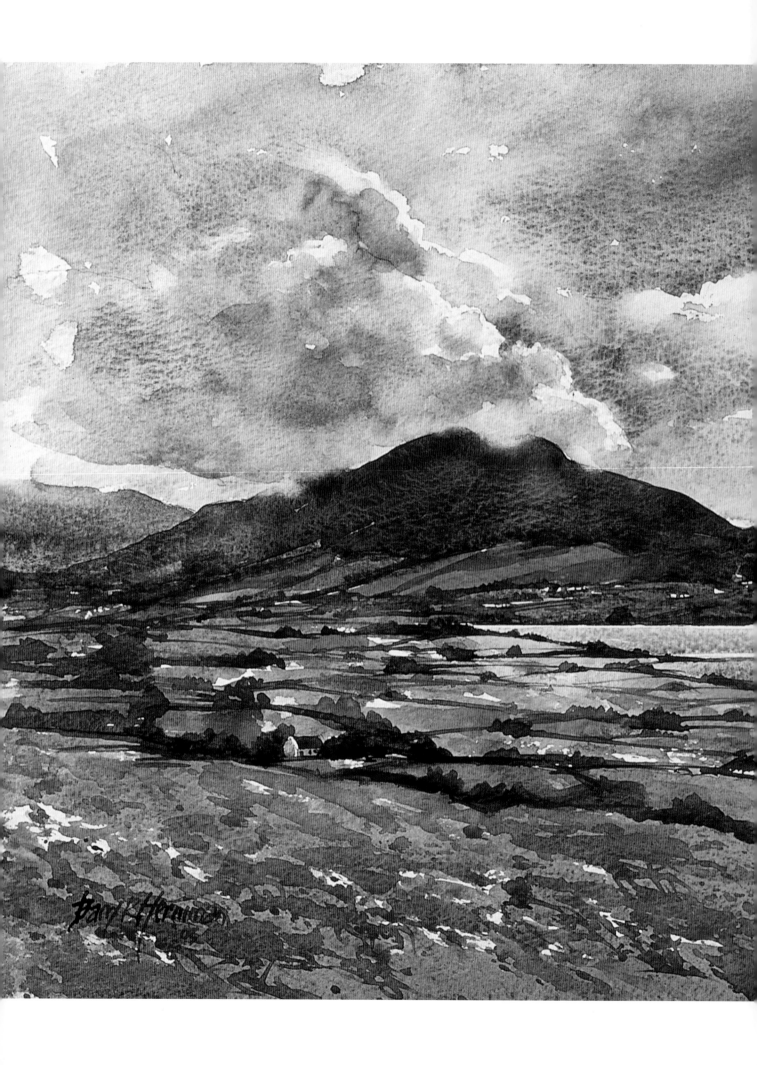

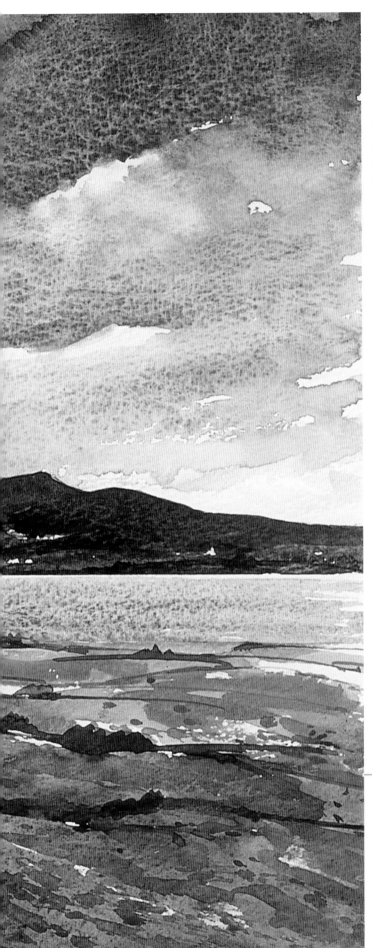

Stormy Skies

Travelling up to Argyll in the west of Scotland, I was greeted with some kind Scottish hospitality and some terrific Scottish scenery. Because the landscape is criss-crossed with so many lochs and valleys, the weather systems tend to move through at a considerable rate of knots. Wait five minutes and you can have a complete change of weather! All this adds up to some pretty dramatic skies and it is one such sky that I want to portray in this demonstration.

I took several photographs, all of which had completely different skies. In the one used as the reference for this painting, I managed to catch the scudding clouds as they clipped the top of the mountains. The clouds were quite dark and foreboding, but they had a tremendous luminosity that made them shimmer.

The natural tendency is to make dark clouds much too dense and heavy, especially when working from photographs. I recommend that you try to keep your skies light and airy and very transparent, even when dealing with storm clouds. If you do not, you could end up with a rather clumsy result.

You will need:

Watercolour paper, Not surface, 640gsm (300lb), 40 x 30cm (15¾ x 11¾in)

Watercolours: Indian yellow, quinacridone gold, cobalt blue, French ultramarine, manganese blue, Winsor red, rose madder genuine, permanent magenta, brown madder

Brushes: Nos. 8 and 12 round, No. 3 rigger

Masking fluid and an old brush

Masking tape

Bristle brush

Paper towel

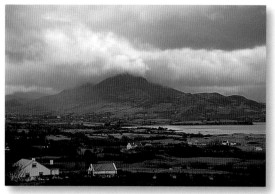

This is one of a series of photographs that I took on a trip to Scotland. I used the photograph and water-soluble pencil sketch above as the reference material for this demonstration.

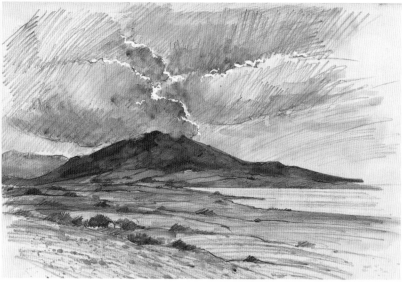

Water-soluble pencils are great for getting texture into tonal studies. Here I used them to get the tones into the sky and land, softening the hatching by rubbing the marks in the sky with my finger. I used a brush and clean water to merge the marks in the mountain area.

1 Sketch the basic outlines of the composition (keep it simple and only include the main elements), then use an old brush to apply masking fluid to some of the cloud edges and to the end of the small house in the middle distance.

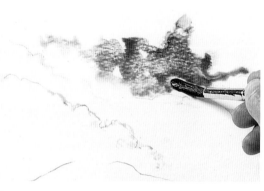

2 Prepare the initial washes: quinacridone gold, French ultramarine, Winsor red, manganese blue, cobalt blue, rose madder and Indian yellow. Wet the top of the paper, then start the sky by introducing French ultramarine, Winsor red, and cobalt blue. Push the brush into the cloud area and roll it from side to side to create texture.

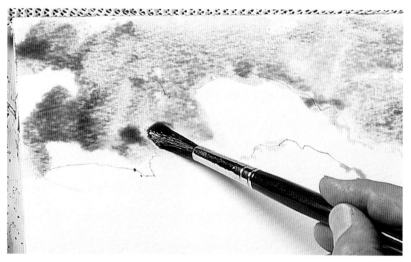

3 Pull the colours down to the top edge of the clouds. Tilt the board to allow the colours to run into each other, then introduce quinacridone gold, with touches of Indian yellow, Winsor red and cobalt blue, to the top left of the wet paper.

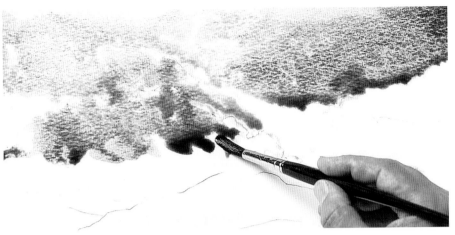

4 Work down the paper, adding more cobalt blue and Winsor red, then soften the tones beneath the clouds with rose madder genuine.

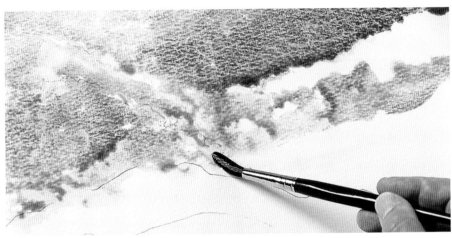

5 Pull the colours down into the mountains, diluting them slightly, then, at the right-hand side of the sky, introduce manganese blue and touches of rose madder genuine.

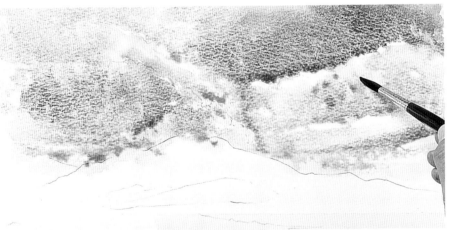

6 Tilting the painting board to allow the colours to flow across the paper, add weaker washes of the sky colours to the lower right-hand side of the sky, softening the bottom edges. Accentuate the billowing clouds with cobalt blue and Winsor red.

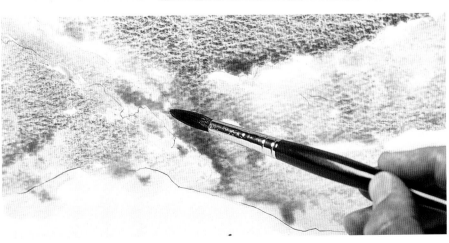

7 Add manganese blue and Winsor red to the centre sky. Touch the tip of the loaded brush on to the surface of the paper and allow the paint to run out into the wet area.

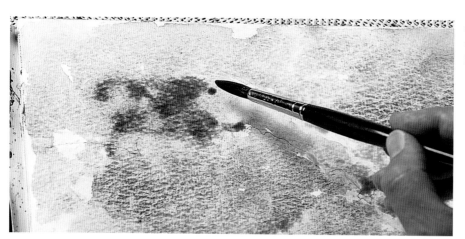

8 Strengthen the top left-hand corner of the sky with more cobalt blue and Winsor red.

9 Use French ultramarine to strengthen the top right-hand part of the sky in a similar way.

10 Allow the sky colours to dry, then, referring to the tip below, apply a strip of masking tape to the top edge of the loch.

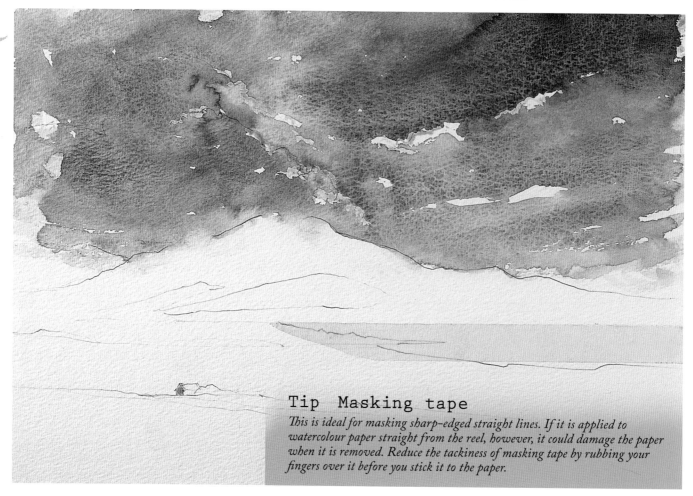

Tip Masking tape

This is ideal for masking sharp-edged straight lines. If it is applied to watercolour paper straight from the reel, however, it could damage the paper when it is removed. Reduce the tackiness of masking tape by rubbing your fingers over it before you stick it to the paper.

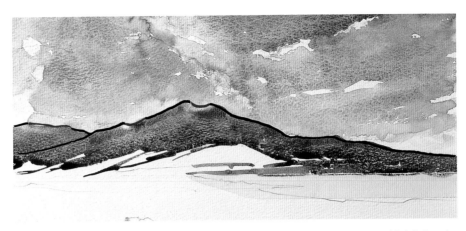

11 Prepare the washes for the landscape: Indian yellow, Winsor red, permanent magenta, French ultramarine, cobalt blue and quinacridone gold.

12 I have highlighted the edge of the mountains above. Wet the areas highlighted in red, then drop in the colours. Use French ultramarine, cobalt blue and permanent magenta on the highest peaks and the other mountains to the right of these, adding touches of quinacridone gold on the lower slopes. Use permanent magenta for the distant mountain at the left-hand side to reflect the pink in the sky. Bring quinacridone gold across from the right-hand side to define the far bank of the loch.

13 Lay in the middle distance area at the left-hand side with quinacridone gold and Winsor red, warming up tones as you move to the right. Use touches of cobalt blue, French ultramarine and permanent magenta to work up shape and form on the far bank of the loch.

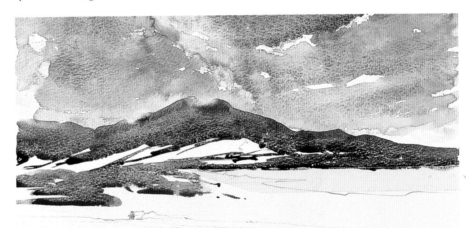

71

14 Dipping a No. 12 brush in quinacridone gold, Indian yellow and Winsor red, work up the lower slopes of the mountain, then work up the foreground area with the same colours, adding touches of permanent magenta and cobalt blue at the right-hand side. Raise the top, left-hand corner of the painting board, then spatter Winsor red, quinacridone gold and cobalt blue over the bottom of the paper.

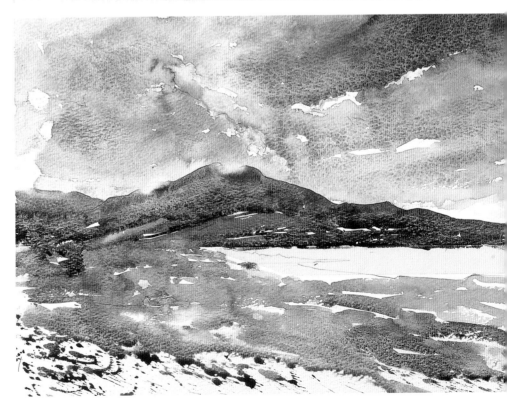

 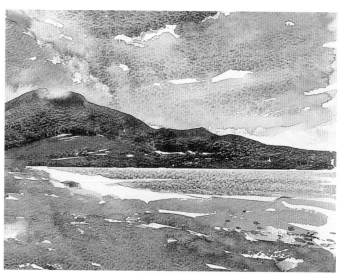

15 Leave to dry, then remove the masking tape to reveal the sharp edge of the far side of the loch.

16 Use a weak wash of manganese blue and long horizontal strokes to block in the surface of the loch, leaving a thin white line below the far shoreline. Lay in touches of permanent magenta across the near side of the loch and allow the colours to blend together. Leave to dry.

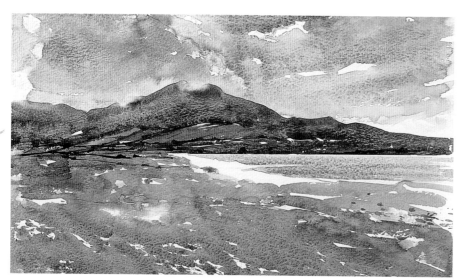

17 Dipping the rigger brush into cobalt blue, brown madder, French ultramarine and permanent magenta, work up shapes on the lower slopes of the mountain (to suggest hedges and foliage) and areas of shadow along the far bank of the loch.

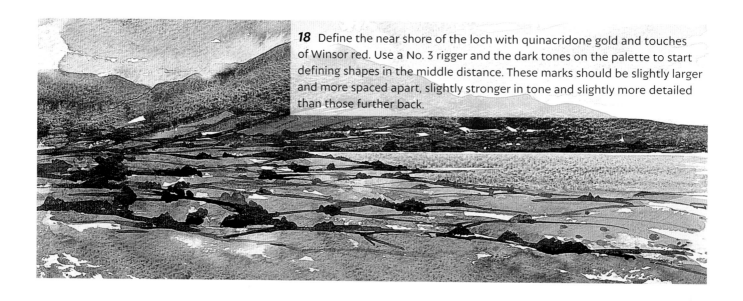

18 Define the near shore of the loch with quinacridone gold and touches of Winsor red. Use a No. 3 rigger and the dark tones on the palette to start defining shapes in the middle distance. These marks should be slightly larger and more spaced apart, slightly stronger in tone and slightly more detailed than those further back.

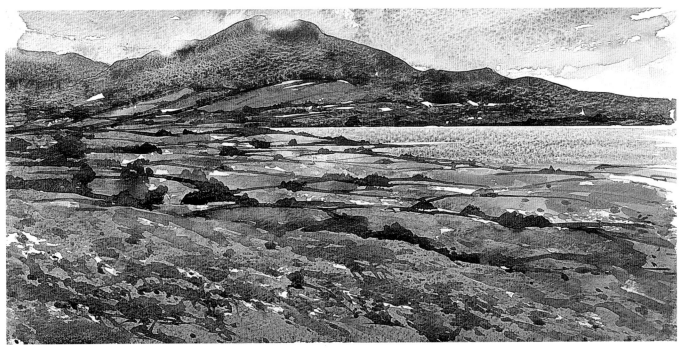

19 Spatter quinacridone gold, Indian yellow and permanent magenta diagonally across the foreground, spatter some smaller spots of manganese blue into these to create slightly darker tones, then use the brush to blend some of the speckles together to form larger marks. Use the darks on the palette to add a hedge to separate the high foreground from the lower land beyond. Leave to dry.

20 Re-wet the soft areas on the mountains, then, dipping a No. 8 brush into French ultramarine, quinacridone gold, permanent magenta and brown madder, apply darker tones to the mountain. Leave to dry completely.

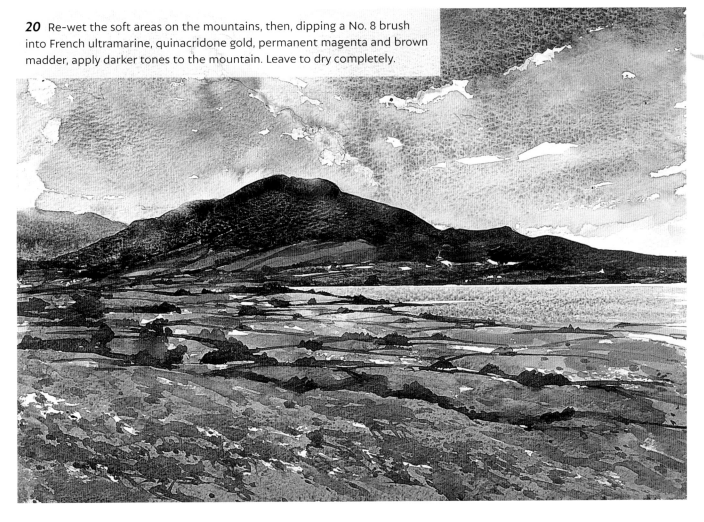

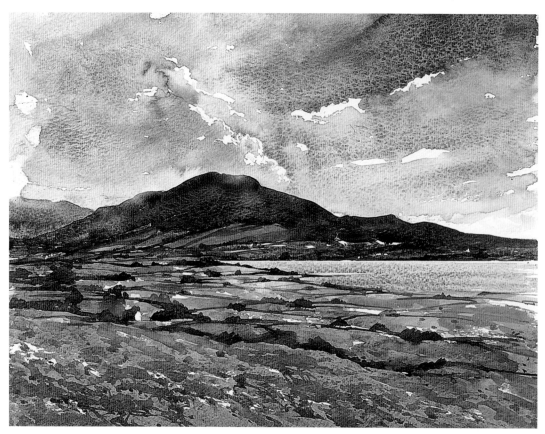

21 Remove all masking fluid. Note that the exposed white areas are very harsh, so they need to be softened in places – we move on to do this over the next steps.

22 Use a bristle brush and clean water to soften the two mist-covered parts of the mountain.

23 While the area remains damp, use a clean paper towel to lift out some of the colour.

24 Now, using the bristle brush and clean paper towel, rework the whole sky, leaving some hard edges, blending some cloud colours and lifting out some colours to create shape and form.

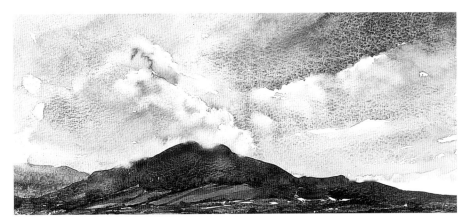

25 Develop shadows in the clouds with permanent magenta, quinacridone gold, cobalt blue and tiny touches of brown madder and French ultramarine. Work small areas at a time, wetting the paper then dropping in the colours.

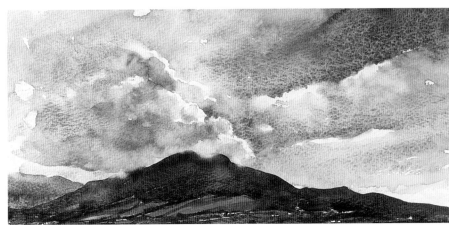

26 Use the darks on the palette to add detail to the small house in the near middle distance. Add small marks to the white patches on the distant shore of the loch to suggest buildings. Strengthen the tones of the foliage between the foreground and middle distance to finish.

The finished painting can be seen on pages 66–67.

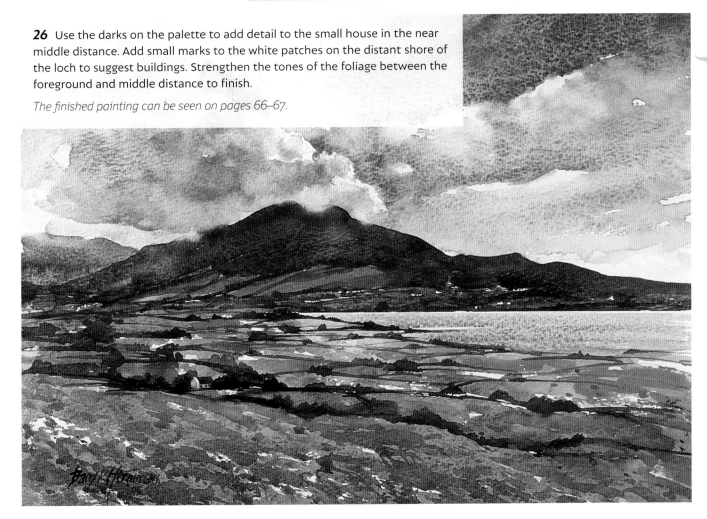

WEATHER

It had been threatening to rain all morning when I came across this loch in Argyll, but the clouds broke and cast a strong light on the water which was counterchanged by the dark shadowy hills in the background. Quite often, awful weather can produce the most wonderful subjects. I have found that often the most dramatic light comes just before or just after a storm where you can experience some really fierce light on the scene.

The painting below was worked up on a large sheet of watercolour paper as a demonstration piece at an exhibition. When you have a large area to cover, it is best to mix up your paints in large wells before the off. Once you start painting, you have to move fast and stopping mid flow can cause some disastrous effects.

The prevailing weather can change the mood of a place very strongly – compare the stormy atmosphere of *Light in the Loch, Argyll*, with the striking sunlight in *A Passing Squall, Llangarron*, where we had just experienced a downpour and the clouds were dispersing. I did this painting as a demonstration, so I had all my component cloud colours ready mixed up. I could therefore go straight into the painting without having to pause to mix more paint. Once again all my colours are mixed on the paper and not in the palette, some wet on dry and others wet in wet.

LIGHT ON THE LOCH, ARGYLL
62 x 48.5cm (24½ x 19in)

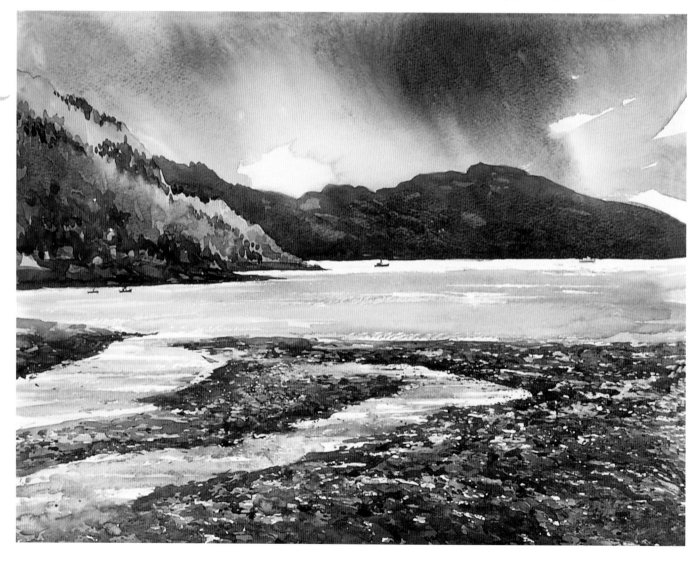

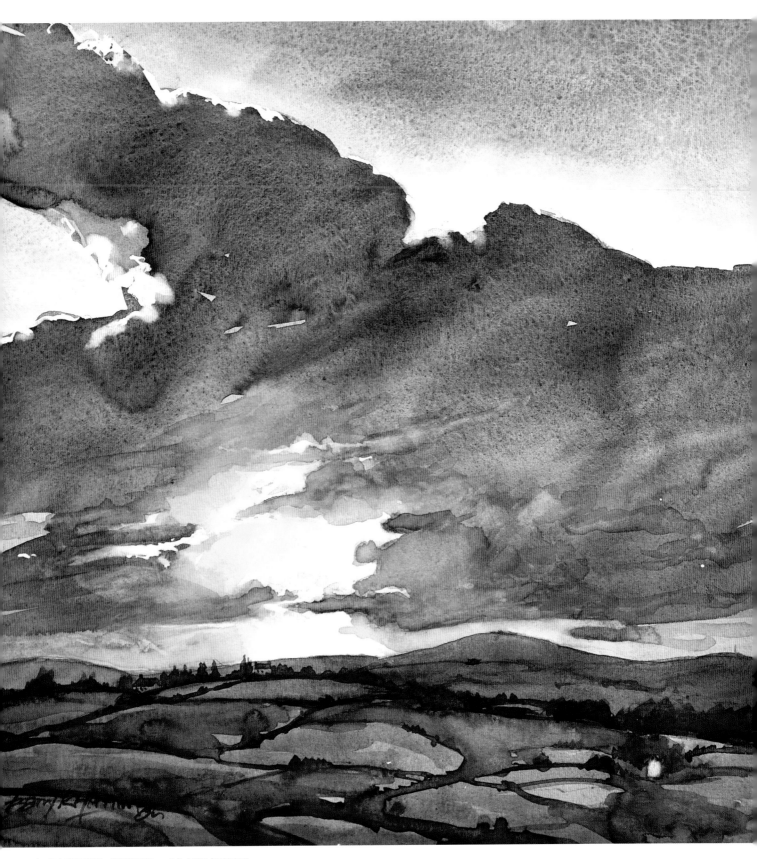

A PASSING SQUALL, LLANGARRON
30.5 x 30.5cm (11¼ x 11¾in)

STILLNESS

In complete contrast to the moody scenes on the previous page, the view of snow on moorland below is much more mellow. This doesn't mean it lacks atmosphere, however. Instead, such still scenes evoke a more subtle, reflective mood.

The moors are so open and vast that you feel as if you're the only person around, even on a sunny day. When there is a fall of snow and a strange quietness pervades the whole area, the effect is even more apparent. I loved the aerial perspective of the three distinct divisions: the shadow covered background, the sunlit and sparsely snow-covered mid ground and the snowy foreground, covered with dark gorse and heather.

Where Quiet Waters Flow (see opposite) is another painting from the Watersmeet area of Exmoor. We followed the sylvan river all the way down the valley to Lynmouth, and found this view at water level where the rocks and boulders predominate and the water glides gently amongst them. It is difficult to imagine that this idyllic scene had became one of awful devastation: on the night of 15th and 16th August 1952, debris-laden flood waters thundered down the valley. Whole houses were swept away and thirty-four lives were lost. Many of the boulders now present were moved to this location by the flood waters.

I used masking fluid very sparingly, mostly on the highlights of the water to guarantee their pure whiteness . The highlights on the rocks were left untouched whilst painting in the shadow areas.

SNOW ON NORTH YORKSHIRE MOORS
38 x 28cm (15 x 11in)

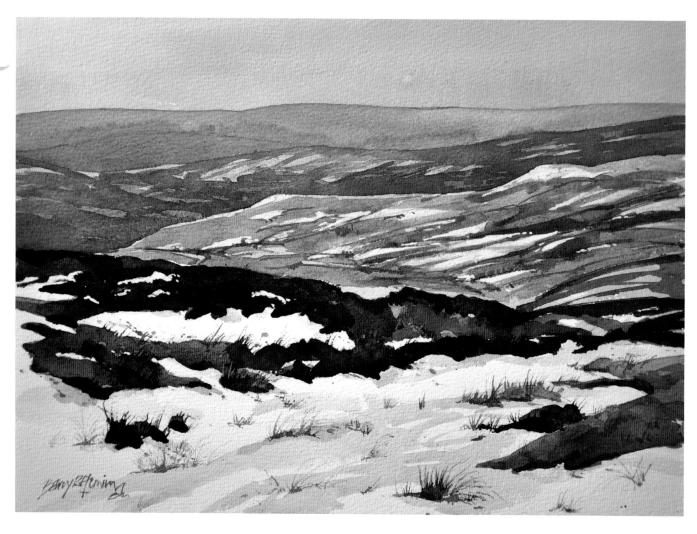

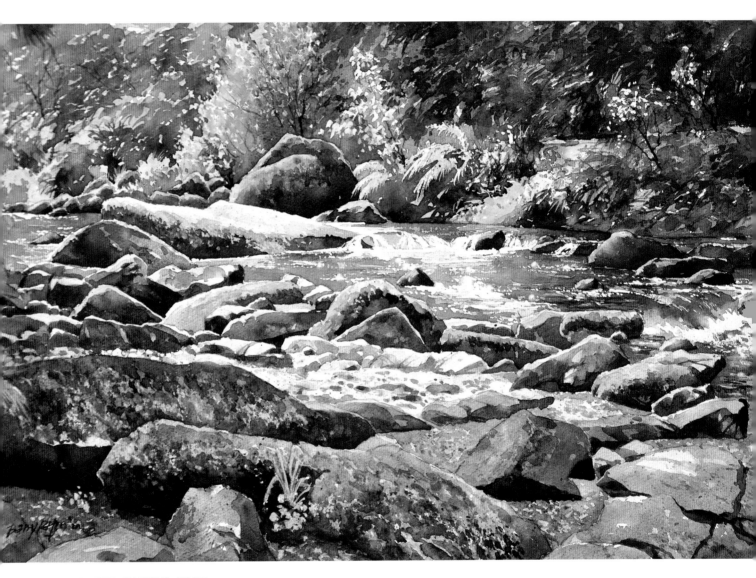

WHERE QUIET WATERS FLOW
56 x 38cm (22 x 15in)

Weathered Timbers

New England is a magical place with its lakes, mountains, rivers, streams and wonderful wooden buildings. In autumn, when the trees take on their fall colours, it is even better. This cluster of timber barns caught my eye while travelling up into the Green Mountains of Vermont late in the afternoon. The light was catching the corrugated tin roofs, creating some striking shapes and contrasts, and the well-weathered clapboard sides of the old barn produced some lovely textures. For me it was a perfect combination, so I took the opportunity to take several photographs and copious notes.

 I used one of these photographs as a reference for this demonstration in light and shade, playing off the harsh angular lines of the buildings against the softer, rounder shapes and random quality of the foliage and undergrowth. I like the finished painting very much, so I think I will be painting these buildings quite a few more times before I tire of them.

You will need:

Watercolour paper, Not surface, 640gsm (300lb), 30 x 40cm (11¾ x 15¾in)

Watercolours: quinacridone gold, alizarin crimson, permanent magenta, Winsor red, cobalt blue, cobalt turquoise light, manganese blue, French ultramarine, brown madder

Brushes: Nos. 10, 12 and 16 round, No. 3 rigger

White gouache

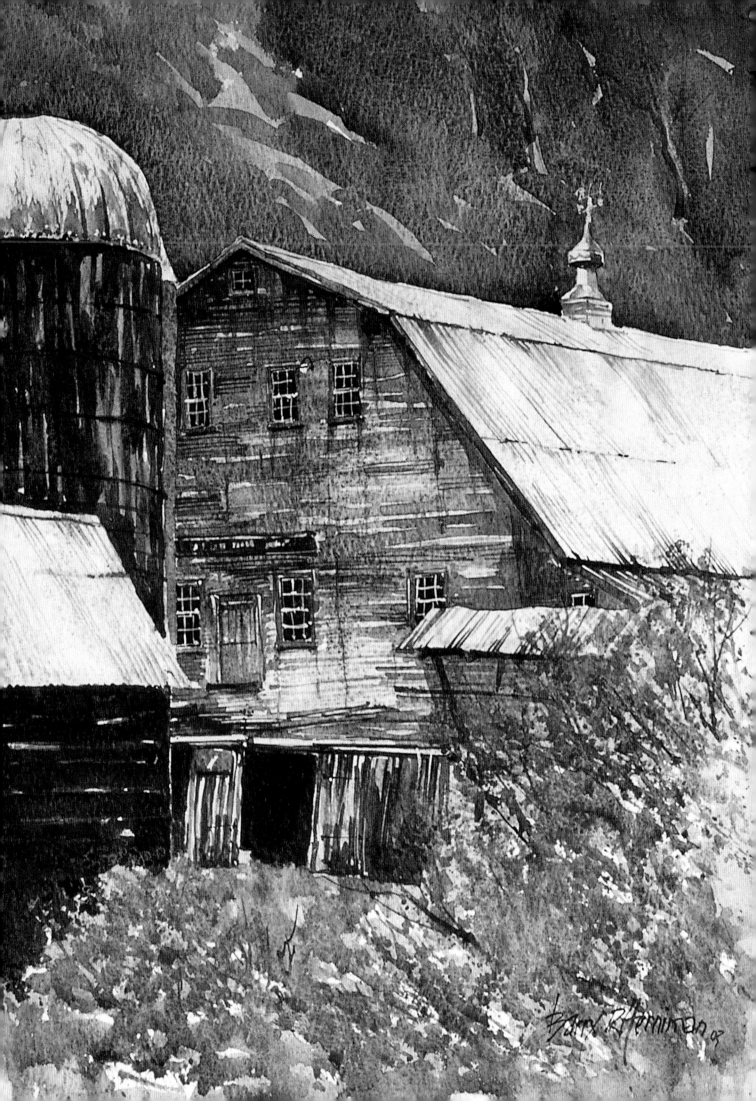

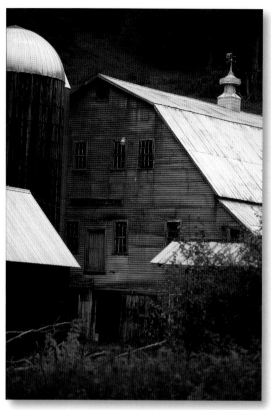

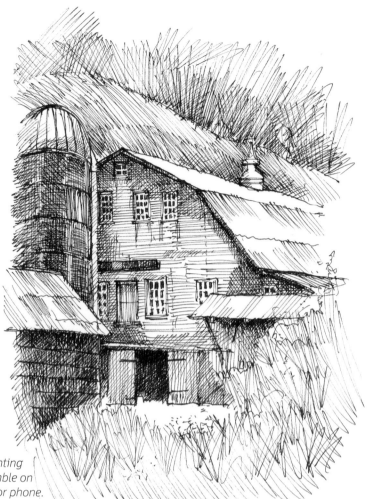

One of several reference photographs taken during a painting holiday in Vermont. You never know when you might stumble on scenes such as this, so never travel without your camera or phone.

The quick tonal sketch (see right) was worked up with sepia ink, using cross hatching to build up the dark areas. You cannot rub out ink, so all the lines have to be decisive and bold.

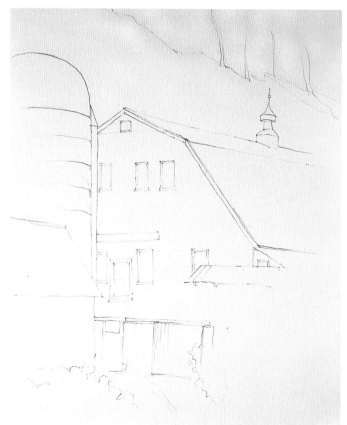

1 Referring to the tonal sketch and photograph on page 54, use a 2B pencil to transfer the basic outlines of the composition onto the paper.

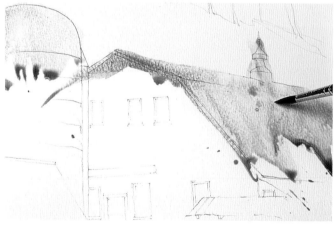

2 Prepare the initial washes: cobalt blue, quinacridone gold, permanent magenta, cobalt turquoise light, alizarin crimson and manganese blue. Wet the top edges of the buildings, then use the No. 16 brush to lay manganese blue into the roof of the large building and the top of the silo. Working quickly pull the colour down the paper (roughly following the shape of the roofs) and drop in touches of alizarin crimson, cobalt turquoise light and permanent magenta.

3 Continuing to work wet-in-wet on the buildings, pull the existing colours down the paper, adding more colour as shown, and allowing these to blend together to create the desired tonal effect.

These images show the progression of colours during step 3.

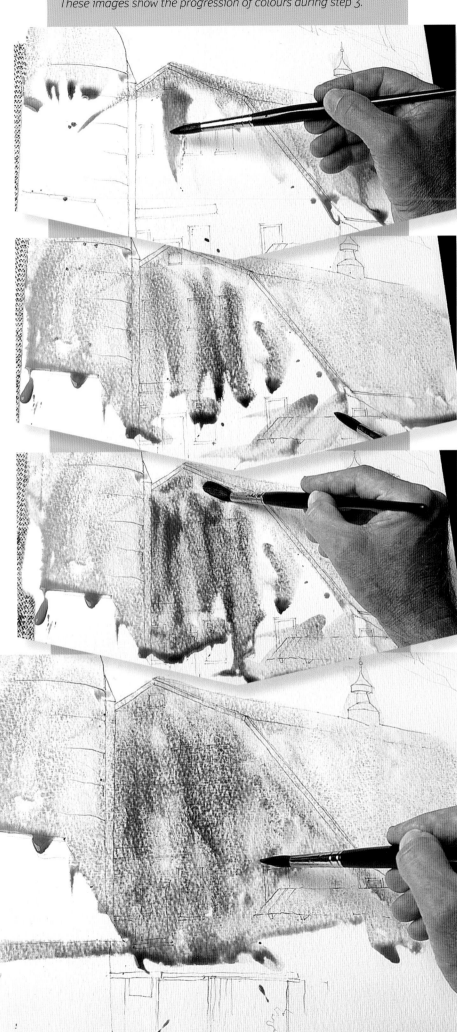

The painting at the end of step 3.

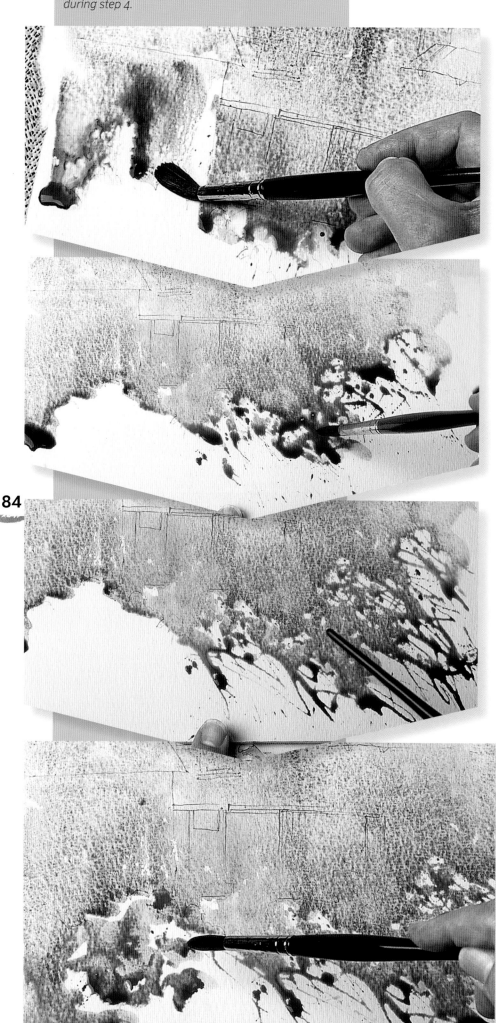

These images show the progression of colours during step 4.

4 While the colours are still wet, start to work on the foreground. Develop the background tones for the two smaller buildings, centre and left, then start to work up the foliage. Use a No. 8 brush to spatter quinacridone gold, permanent magenta and cobalt blue, then use the handle of the brush to draw some of the spatters together to create the rough texture of foliage. While these colours are still wet, flick in some bright accents of cobalt turquoise light.

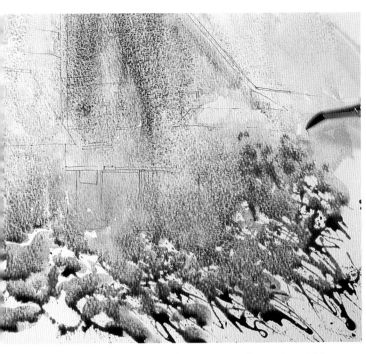

5 Mingle and merge the colours across the entire width of the foreground, then complete the initial washes by spattering colour up into the damp area of the buildings at right-hand side to suggest more open foliage.

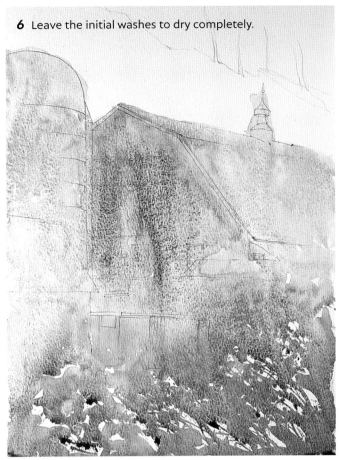

6 Leave the initial washes to dry completely.

7 Turn the painting upside down, then, working down from the hard edges of the tops of the buildings, lay in the background washes of quinacridone gold with touches of manganese blue and cobalt blue. Start wet on dry, then work fresh colour into the wet ones on the paper.

8 When the background wash is complete, leave the painting to dry.

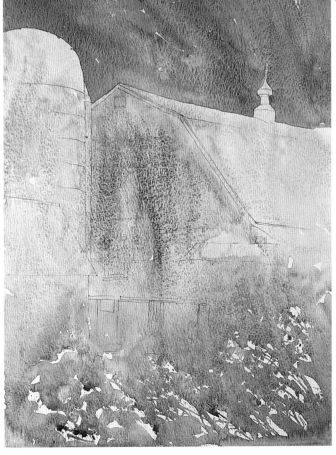

9 Use a No. 10 brush with brown madder and touches of French ultramarine to work on the grain silo. Drop in colour along the top edge of the side of the silo, then drag down streaks of rust and water marks. Cut along the edges of the roof of the building in front of the silo. Spatter on a few specks of quinacridone gold and allow these to blend with the darks. Using the handle of the brush, draw through the wet paint to indicate the curved sections of the silo.

10 Turn the painting on its side, then use the same colours to paint the planking of the wall on the small building below the silo.

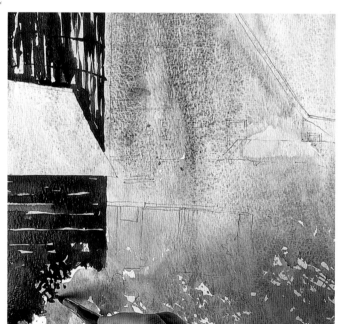

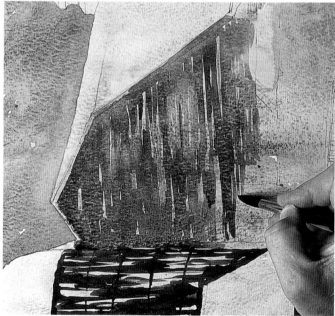

11 Continue working down to the top of the foliage, turn the painting right way up, then trickle colour along this edge. Soften some of the marks with clean water.

12 Turn the painting on its side and use the No. 10 brush with cobalt blue, manganese blue, permanent magenta, Winsor red and French ultramarine to lay in the planking on the large building. Work wet on dry, then wet in wet, laying in streaks of colour. Suggest the deep shadow under the eaves with darker tones.

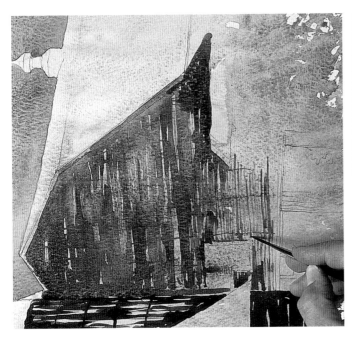

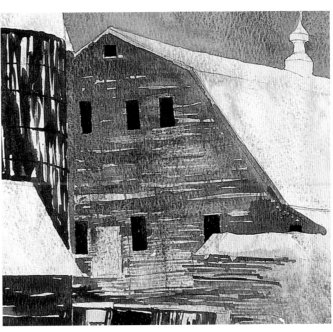

13 Continue working colour into colour to build up random tones, then use the handle of the brush to reinstate the outline of the doors and windows. The bottom of the building has reflected light from the structures around it, so use the rigger brush to define the planking in this area.

14 Cut round the small pitched roof on the front of the building, turn the painting the right way up, then use a mix of French ultramarine, permanent magenta and brown madder to block in the windows. Use the same colours to start defining the shapes for the foreground building.

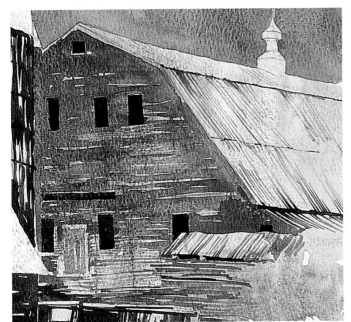

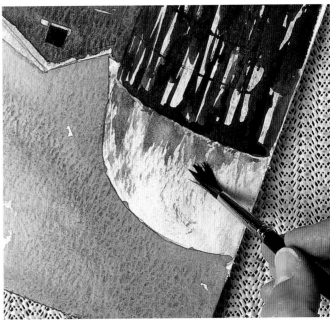

15 Block in the long signboard above the door, then use the rigger brush with manganese blue, permanent magenta and cobalt blue to develop the texture on the corrugated iron roofs. You only need an impression, so do not try to reproduce every undulation. Then, using the darks on the palette, define the shadows along the edges of the roof.

16 Turn the painting upside down, then use a semi-dry brush loaded with cobalt turquoise light and permanent magenta to paint the top of the silo; drag the brush lightly over the undercolour, varying the angle of the stokes to follow the curve of the top of the silo.

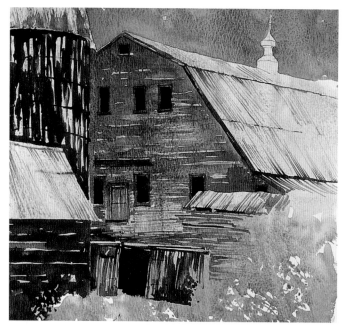

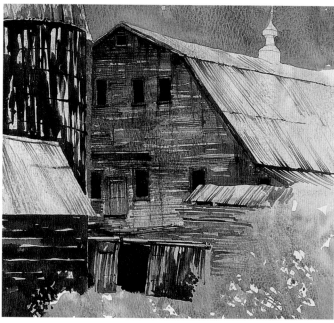

17 Define the corrugations on the roof in front of silo as before. Then, still using the rigger and a mix of cobalt blue, quinacridone gold and permanent magenta, define the window frames and doors on the barn. Use the same colours to paint the barge boards that edge the roof.

18 Use the rigger brush with French ultramarine, cobalt blue, brown madder and a touch of alizarin crimson to lay in deep shadows under the eaves; pull down vertical streaks of colour to suggest water stains. Darken the left-hand side of the large building so that the second silo becomes obvious.

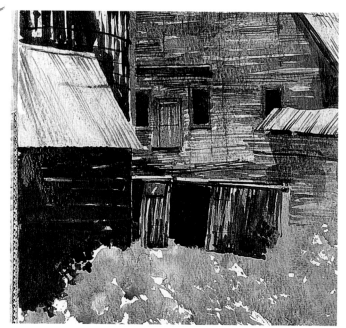

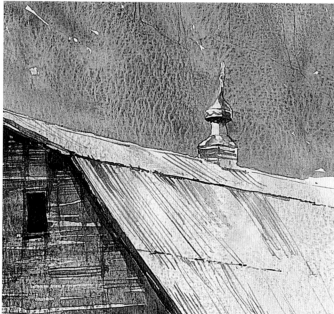

19 Use the same colours to strengthen the tones on the front of the left-hand building.

20 Use the rigger to define the detail on the air vent.

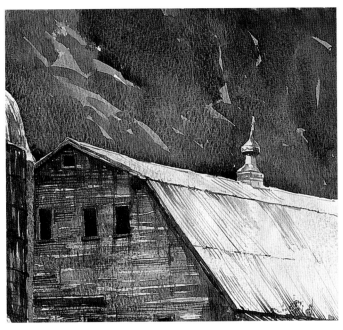

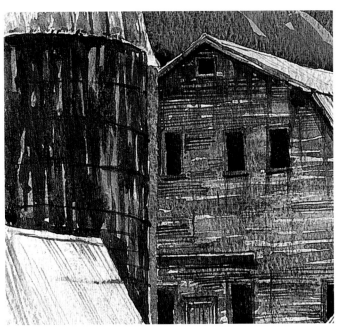

21 Develop the background. Use the No. 12 brush with quinacridone gold, cobalt blue and touches of permanent magenta to lay in random patches of dark tones to suggest foliage. Carefully cut around the shape of the air vent and the top edge of the roofs.

22 Lay in a wash of quinacridone gold over the right-hand side of the silo.

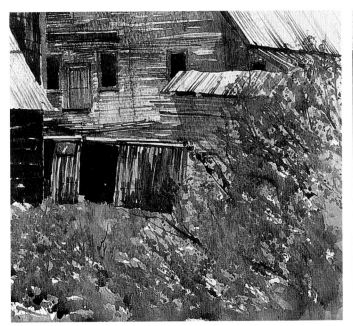

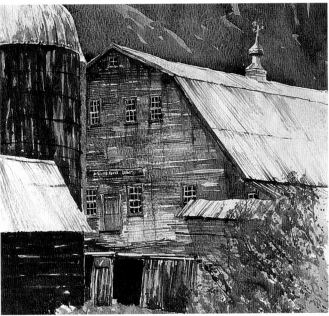

23 Develop the foreground foliage by spattering all the colours in the palette. Scrape the handle of the brush through the spattered colours to suggest stalks and twigs.

24 Working on a separate palette, tint some white gouache with touches of cobalt turquoise light and a brown from the watercolour palette, then use the rigger to define the window bars and to suggest wording on the sign. Step back from the painting to assess it and check all the details are in place.

The finished painting can be seen on page 81.

Tip - Assessing

I realized that I had omitted the support for the small pitched roof on the front of the barn. I painted this with a rigger brush and a mix of brown madder and ultramarine, then added more foliage to cover the bottom of the support.

BUILDINGS AND STRUCTURES

Buildings and other manmade structures take a variety of shapes and forms, which can help to produce some incredibly moody subjects to paint. Once again, light plays an incredibly important part in turning what might be an ordinary view into an extraordinary one. Watch out for all that lovely light play and the resultant shadows that add so much to the structure.

The painting opposite, *Ferbotnik's Porch, Pennsylvania*, is a scene of strong light and sharp contrasts. This wonderful porch was built on to the side of an old farmhouse in Bucks County – a very pretty county in Pennsylvania. I was on a search for old-style barns and bridges and came across this farmstead with its coloured timber frame and doors. With the kids' bikes plonked up against the wall, this scene said 'lazy days' to me. The afternoon sun was catching the pink uprights of the porch, contrasting with the darker red doors.

The small coastal village of Alcaufar in Menorca is always a favourite with everyone on my painting trips – there are painting subjects everywhere. The quaint buildings lining the water's edge are a joy to paint; and the small painting below was done to demonstrate how to paint light in shadows. The ever-present Mediterranean sunlight means there is always a degree of reflected light in the shadows, which makes them glow. Too often I have seen sun-laden shadows applied with blue-grey washes regardless of what is actually there. This can give the whole painting a very cold feel rather than the rich warmth of the sunlit reality.

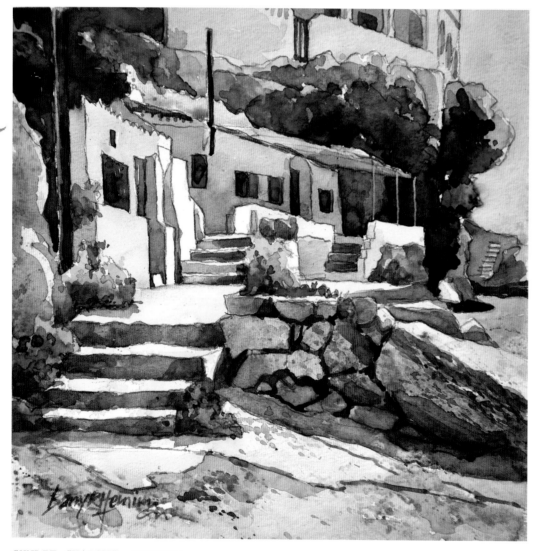

SUNLIT SHADOWS, MENORCA
30.5 x 30.5cm (11¾ x 11¾in)

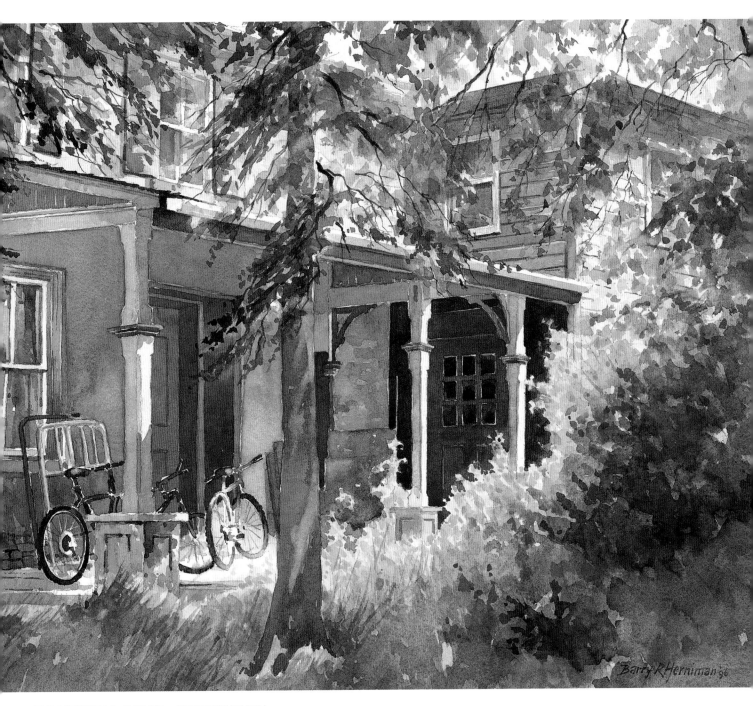

FERBOTNIK'S PORCH, PENNSYLVANIA
52 x 34cm (20½ x 13½in)

Using structures in your painting to create a mood

As mentioned earlier, light plays such an important role in imparting mood into a structure scene. The two examples here show how the light conditions and time of day affect the overall mood of the scene. Whether it's one of strong accents and drama or a softer, more mellow scene, a structure can add an extra dimension and focus to a painting.

This magnificent Roman bridge is tucked away behind a curtain of trees a few miles out of the small Cretan village of Vrisses. Walking around the area I found a path down to the dry river bed, which gave me a stunning view of the bridge in almost full shadow; apart from just under the right-hand arch, which caught the full sunlight. There were also some very strong lights and shadows in the river bed. When out and about it's always worth spending time wandering around your chosen subjects as you may find an alternative and better viewpoint that may not be instantly obvious from the start, just like this view of the bridge.

Zuheros is a small village perched on the side of a mountain in Subbetica Natural Park – a two-hour drive north of Malaga. This is a study of light and shade with underlying warmth. Although more than half of the picture is in shadow, it is not cold, as I infused the shadows with rich, warm reflected colours, which make them glow. When it is hot here, it is very hot, so I bleached out some of the colour from the sunlit areas to intensify the feeling of heat.

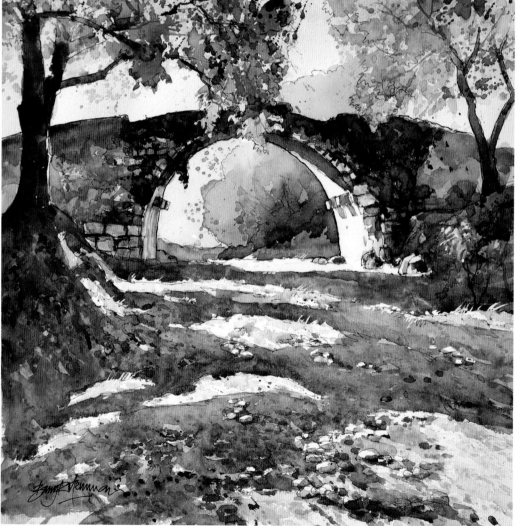

ROMAN BRIDGE, VRISSES
40 x 40cm (15¾ x 15¾in)

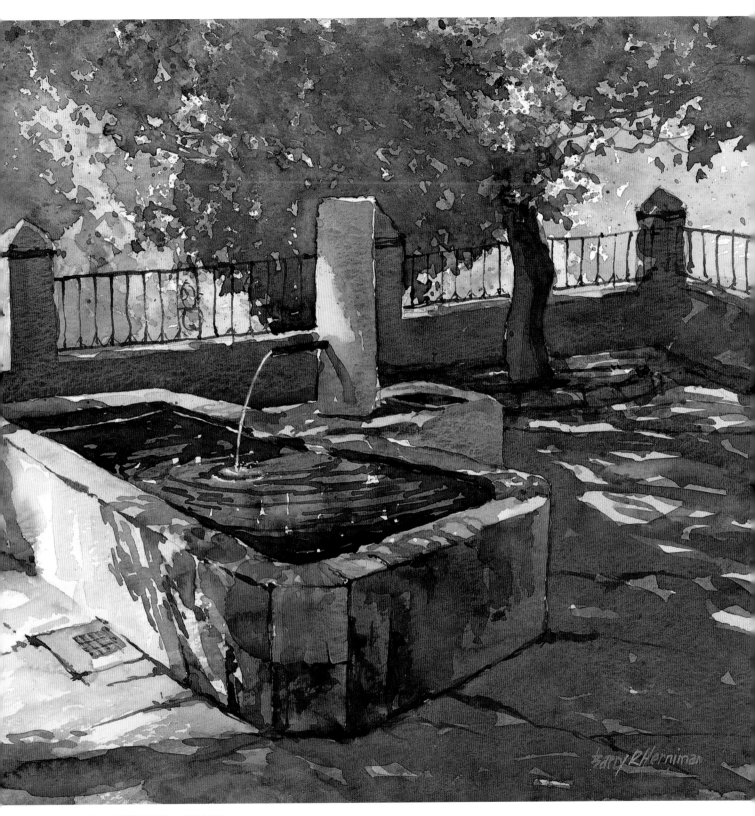

LA FUENTE, ZUHEROS, SPAIN
39 x 28.5cm (15¼ x 11¼in)

Frosty Morning

When you have lived in an area for a while, it is easy to become complacent with the surrounding scenery – familiarity breeds contempt, and all that! You tend to go searching further afield (excuse the pun) for that great subject, when it could be waiting for you just round the corner.

This is a scene from my small corner of Herefordshire. I know every inch of these fields, but it never ceases to amaze me just how different the scene becomes when the light changes and the seasons move on. It just goes to show that the combination of weather, lighting and season can produce some wonderful painting subjects right on our doorsteps.

On this particular late autumn morning, the first frosts had arrived. The air was crisp and clear, and the sun had just risen above the background hills. There was a lovely warm glow over the whole of the countryside, and the sun was shining through the trees in the foreground. Because of this, I was able to look directly at the scene without being blinded and capture the bright light that silhouetted the trees.

You will need:

Watercolour paper, Not surface, 640gsm (300lb), 40 x 30cm (15¾ x 11¾in)

Watercolours: aureolin, Indian yellow, quinacridone gold, Winsor yellow, rose madder genuine, Winsor red, cobalt blue, French ultramarine, manganese blue, brown madder

Brushes: Nos. 8, 10 and 12 round, No. 3 rigger

Bristle brush

Water sprayer

Paper towel

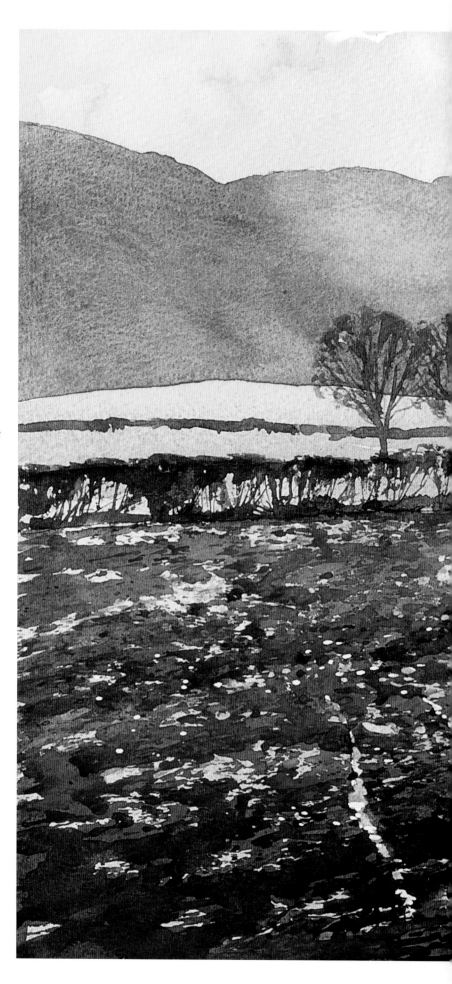

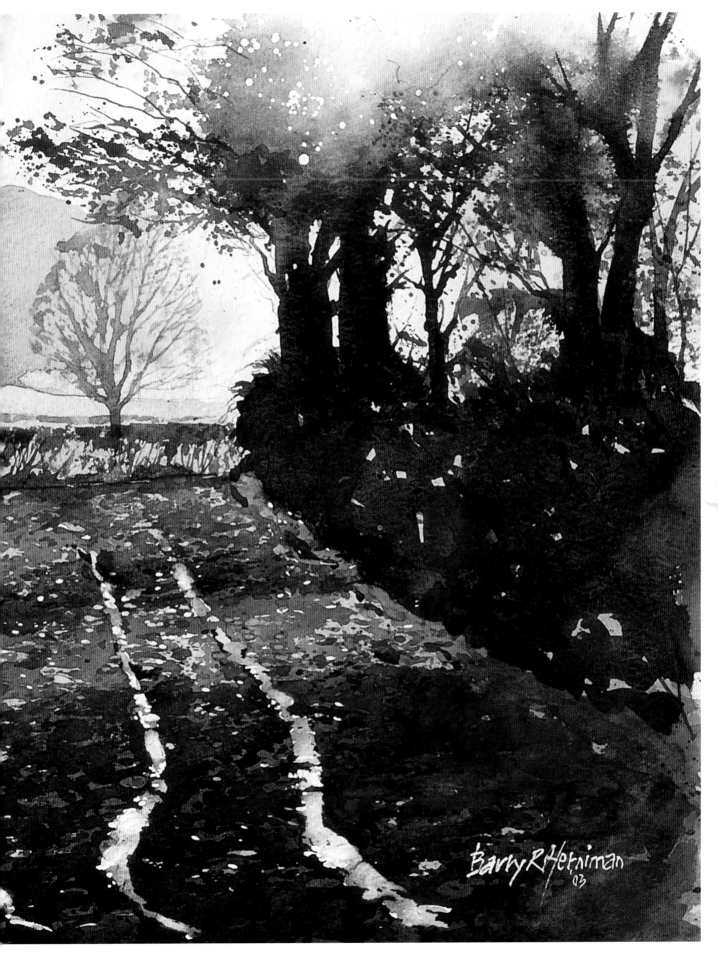

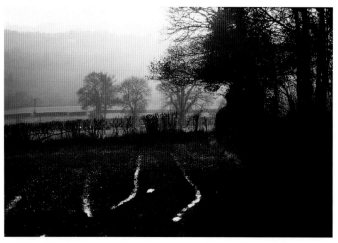

The source photograph captures the high-contrast impact of the sun shining through the trees.

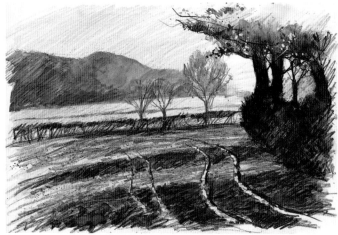

I got out my water-soluble coloured pencils for this quick preliminary sketch. I hatched in yellow over most of the picture, leaving white areas around the trees, built up the colours with a series of overlays, then softened some of the areas with clean water. Note that I changed the angle of the tractor tracks so that they entered the composition from the bottom-right.

1

2

3

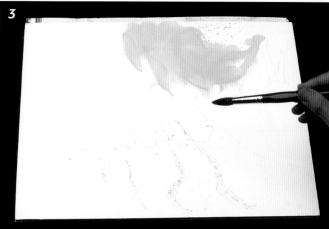

1 Transfer the main outlines of the composition onto the watercolour paper. Note that the detail on the left-hand side of this composition is barely suggested. Apply masking fluid (tinted here with a touch of manganese blue) to the icy water in the wheel ruts in the field. Spatter some into the top of the tree at the right-hand side, then across the foreground as frosty highlights on the ploughed field. Prepare the initial washes: aureolin, Indian yellow, quinacridone gold, Winsor yellow, Winsor red and manganese blue.

2 Use the spray bottle to spray a liberal amount of clean water over all the paper.

3 Working quickly and leaving the highlight area among the trees as white paper, start to lay in Winsor yellow, aureolin and Indian yellow.

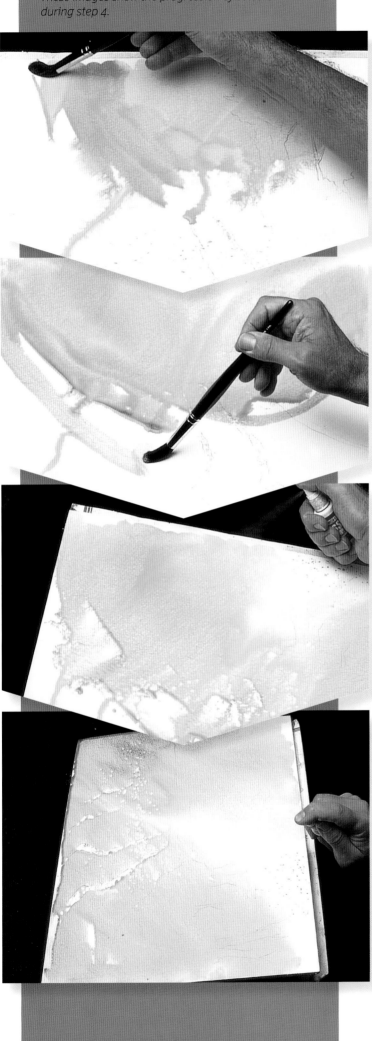

4 Continue building up colour across the paper, spraying the paper with clean water at regular intervals and tilting the painting board to allow the colours to flow into each other. Introduce touches of Winsor red and quinacridone gold. Keep the highlight area clear of colour by tilting the top of the painting upwards and spraying with clean water.

97

These images show the progression of colours during step 5.

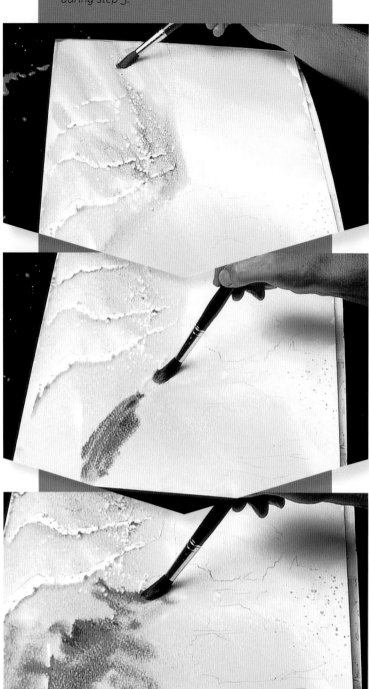

5 Still working quickly, wet in wet, add more Indian yellow at both the left- and right-hand sides. Lay in a weak wash of manganese blue to define the background area where the hedges are. Add Winsor red and quinacridone gold across the right foreground area, then spatter more quinacridone gold wet in wet.

When laying in my initial washes, I am continuously tilting and turning the paper to allow the colours to blend on their own. In the series of photographs here, the top of the painting is at the right-hand side.

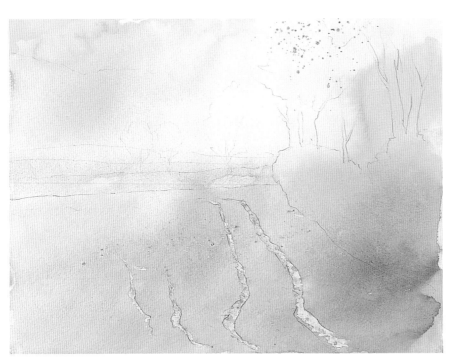

6 Leave the initial washes to dry.

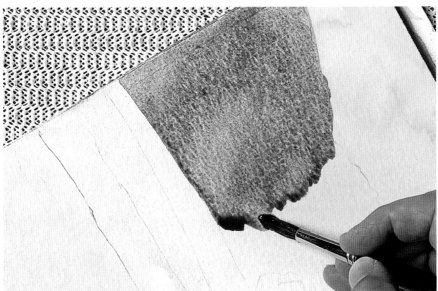

7 Turn the painting on its side, then, working wet on dry, use the No. 12 brush to apply cobalt blue, with touches of French ultramarine and rose madder genuine, into the distant hillside.

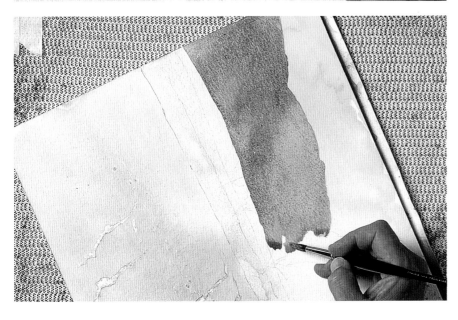

8 Work down (across) the paper, adding more of the same colours, and introducing Winsor yellow to give a warmer glow towards the right-hand trees.

9 When you get close to the right-hand trees, spray the Winsor yellow with water, then use paper towel to absorb any excess paint.

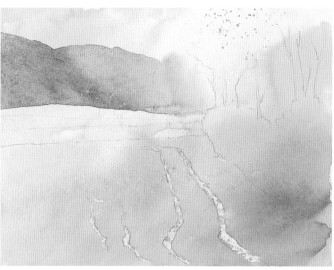

10 Leave the painting to dry.

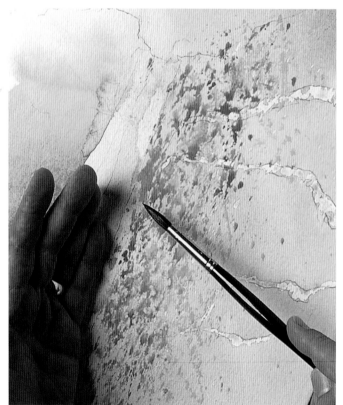

11 Turn and tilt the painting board, then use the No. 10 brush to spatter the foreground with water followed by Winsor yellow and quinacridone gold. Use your other hand to mask the edge of the field.

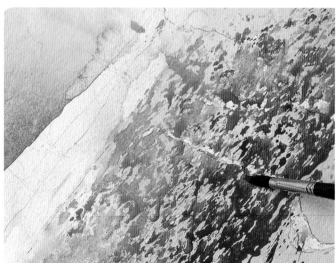

12 As you work down the field, spatter more water followed by Winsor red, more Indian yellow and brown madder. Spatter some cobalt blue to create darker tones. Gently move the paint around with the brush to pull the colours together.

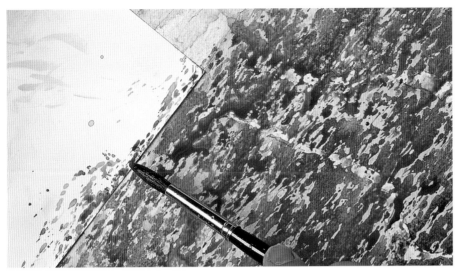

13 Mask the middle distance with a sheet of paper, then, tapping the side of a loaded brush with your finger, spatter smaller marks of the previous colours over the foreground.

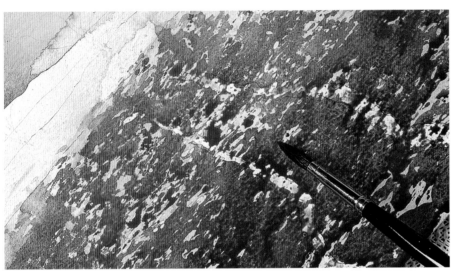

14 Darken the right-hand corner of the foreground with cobalt blue to create shadow areas. Then, keeping the painting angled down so the paint runs and colours mingle, bring this colour across over the centre of the foreground. Use the brush to soften the edges.

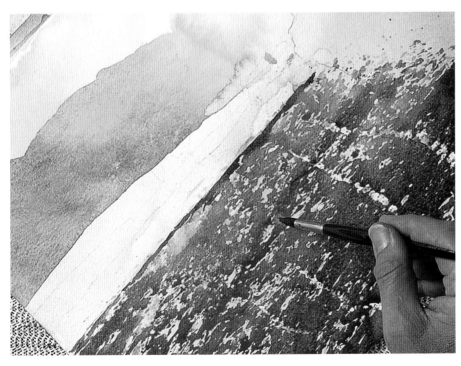

15 Use cobalt blue and brown madder to introduce a shadow area under where the hedge will be. Use the same colours to work smaller shadows in the field. Leave to dry.

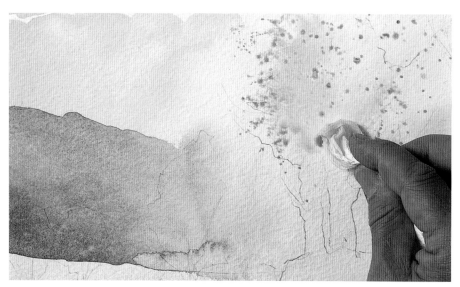

16 Start to work on the right-hand trees. Spray the paper with clean water, then, masking the paper with your other hand, use the No. 8 brush to spatter Indian yellow into the tree. Mop up excess water and colour with clean paper towel.

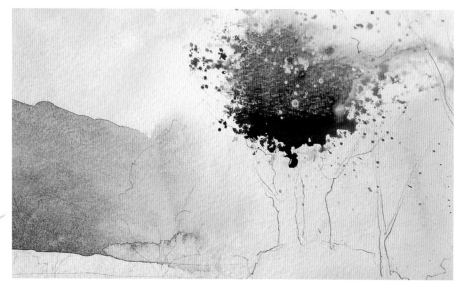

17 Spatter quinacridone gold into the damp yellow and allow colours to merge. Raise the top of the painting, then add brown madder and cobalt blue to the lower area.

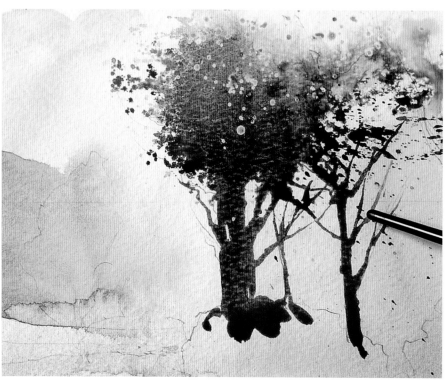

18 Allow the colours to merge then pull the bead of colour down to form the trunk. Use the handle of the paint brush to pull the colour down to form two smaller trees. Spatter dark tones of colour to suggest foliage on these trees.

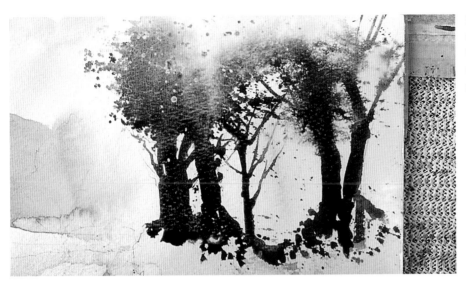

19 Spray the foliage area with water, then paint the two right-hand trees. While the paint is still wet, add touches of French ultramarine on the shadowed sides of the trunks.

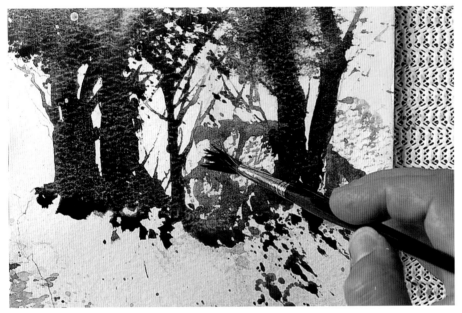

20 Spatter more foliage wet in wet, then pull out more branches. Drag the side of the brush over the surface to create background foliage between the trees.

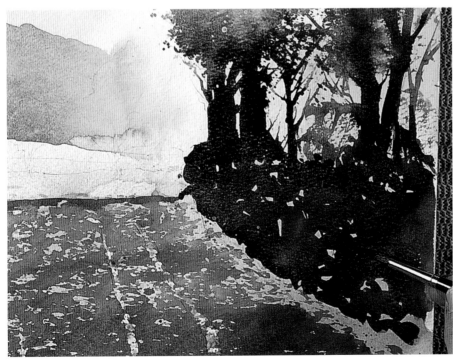

21 Use French ultramarine with touches of rose madder genuine to accentuate the branches and shadows. Bring these colours down over the area beneath the trees, then introduce touches of brown madder and cobalt blue.

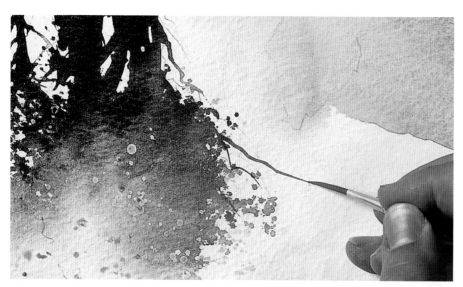

22 Turn the painting upside down, then use the rigger brush with brown madder and cobalt blue to paint some thin branches.

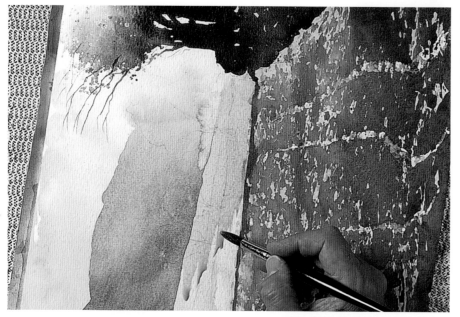

23 Turn the painting on its side so that the colours will run down the paper, then use a No. 12 brush to apply a flat wash of Winsor yellow over the middle-distant fields.

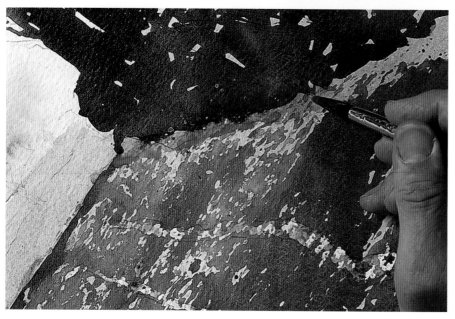

24 Working into the drying edge of the woodland, add a band of Indian yellow down the edge of the field where it meets the wooded area.

25 Still working at an angle, mask the middle distance with paper, then, painting wet on dry, use the No. 8 brush to flick darker tones of quinacridone gold into the foreground field.

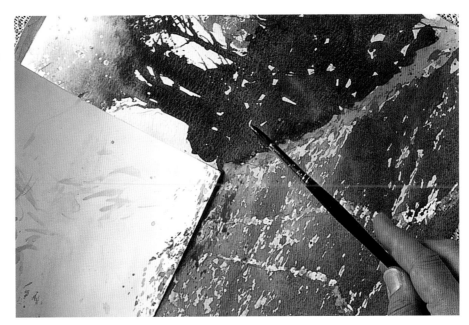

26 Spatter more quinacridone gold, cobalt blue and the reds on the palette into the field, then push and pull the colours together. Develop the distant edge of the field.

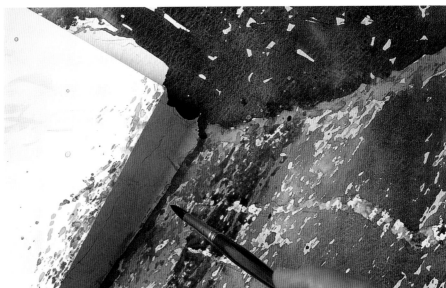

27 Suggest undulations in the field by creating areas of shadow with the dark colours on the palette.

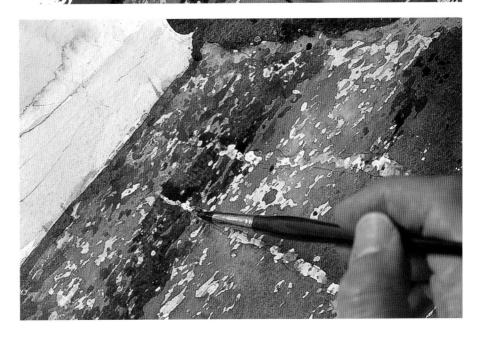

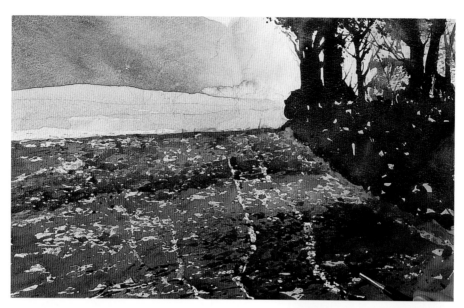

28 Use a No. 10 brush to spatter more reds and cobalt blue on the near foreground. Add touches of French ultramarine, then blend the colours with the brush.

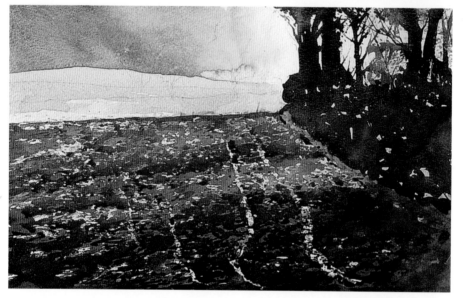

29 Use the same colours to develop the whole width of the foreground. Add some dark shadows at the right-hand side of the field.

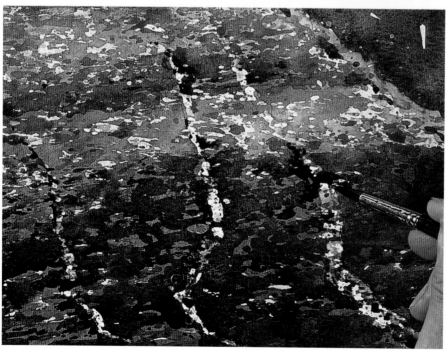

30 Accentuate the ruts in the field by creating shadows with touches of French ultramarine and brown madder. Spatter these colours over the foreground as you work.

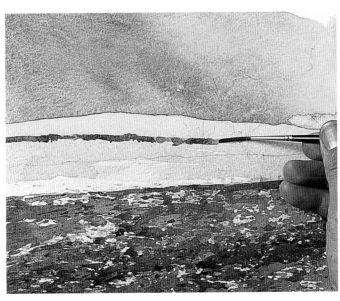

31 Working wet on dry with a No. 3 rigger brush, lay down flat brush strokes of cobalt blue, quinacridone gold, Indian yellow and rose madder genuine to form the more distant of the two hedges.

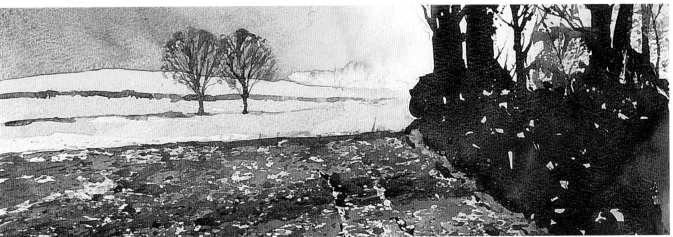

32 Weaken the colours as you work towards the right-hand side. Lay in another band of the same colours to form the nearer hedge. Create the trunks and branches of two trees, then, using a damp brush, drag it across the surface of the paper to suggest some foliage.

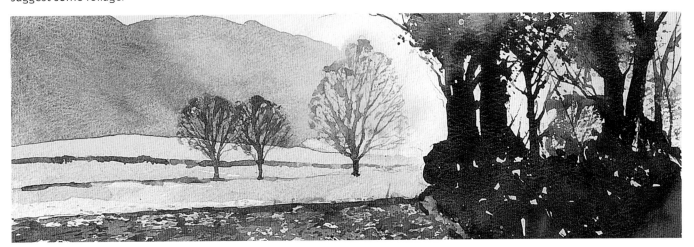

33 Now use a weak brown wash to work up a larger tree to the right of the others. While this is still wet, drop in a blue wash on the shadowed side of the trunk and branches. Work up some foliage with quinacridone gold and touch of brown madder. Notice that there is more detail on the left-hand side; the right-hand side is blurred by sun.

34 Using a No. 8 brush, apply downward, near-vertical, dry brush strokes of brown madder, cobalt blue and quinacridone gold to form the top of the hedge. Use similar colours and upward strokes to form the bottom of the hedge, then use the rigger brush to link the top and bottom parts of the hedge. Add touches of quinacridone gold to the brighter right-hand end of the hedge.

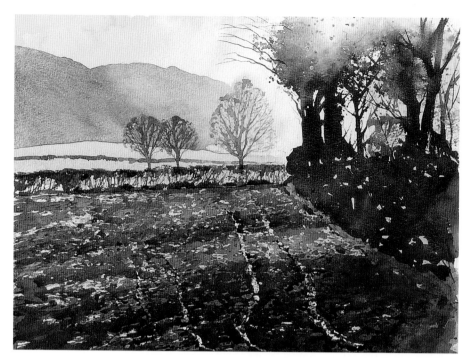

35 Remove all the masking fluid in the field and in the large sunlit tree. To remove large areas of masking fluid, lift one edge and carefully pull the rest off the paper (see inset).

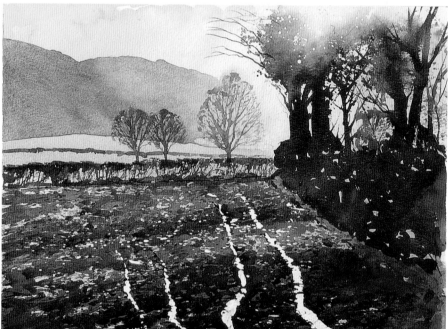

36 Brush Winsor yellow, with touches of quinacridone gold, into the icy ruts in the field and over some of the white highlights created by the masking fluid.

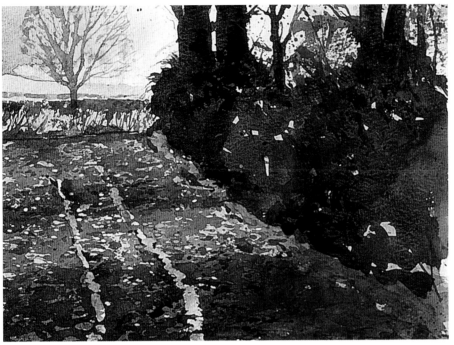

37 Spatter darks from the palette into the deep shadowed area at the right-hand side. Trickle more colour into this area, then use the brush handle to create 'squiggles'. Spatter a few specks of quinacridone gold.

38 Use the No. 8 brush and delicate spattering to suggest foliage on the bare branches of the trees at the top of the painting. Pull the brush handle through the paint to redefine the structure of the branches.

39 Step back and assess whether your painting needs any tweaks. I decided to use a bristle brush, clean water and some paper towel to lift out a few highlights from the icy ruts.

The finished painting can be seen on pages 94–95.

FINDING INSPIRATION IN THE EVERYDAY

How many times have I seen painters wandering around and wasting time trying to seek out that elusive picturesque view when a super subject is right there in front of them? A scene like that below, of some of the myriad stone walls and small enclosures on the small Aran island of Inisheer (*Inis Oírr*) is a perfect example of getting inspiration from what is around you. Here, I loved the way the eye was led through the gate and over the receding walls to the sea. The foreground was bedecked with a stand of ox-eye daisies which I counterchanged against a dark foliage. The daisies were painted in with white gouache for the leaves and orange for the centres.

When I came across the scene that inspired the painting on the facing page, the sunlight shining through the autumn leaves was almost blinding. These leaves were made all the more dramatic by contrasting them with the purple shadows and gravestones. I used pure colours for the leaves: yellows, reds and golds straight from the tube. I just loved the strong contrast between the strikingly bright colours in the foliage against the cool, sombre tones of the gravestones. I have been asked in the past why I wanted to paint a graveyard of all things? I explained that I wasn't painting a graveyard *per se*; but rather the strong overall sense of counterchange between the tree and the gravestones which gave an otherwise ordinary scene a magical buzz.

DAISY FIELD, INIS OÍRR
28 x 38cm (11 x 15in)

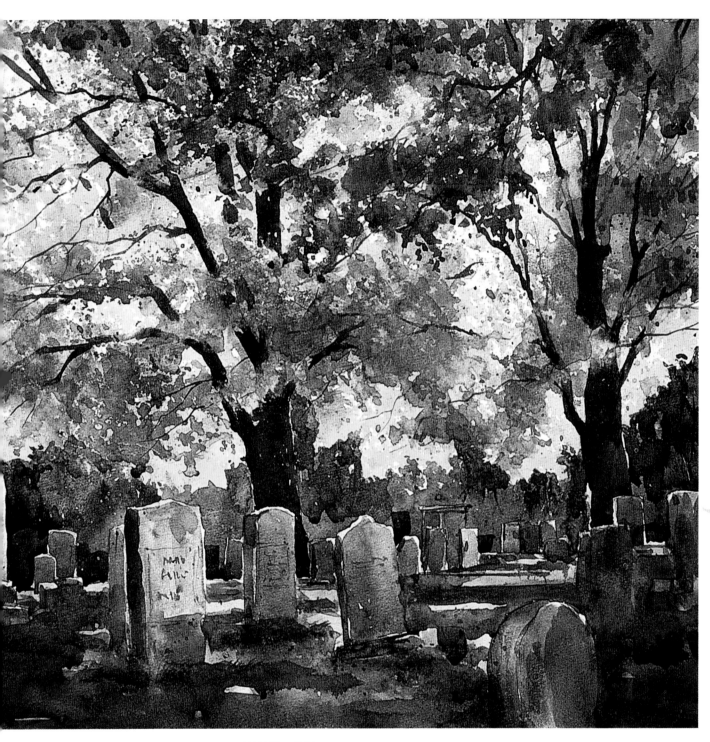

SUNLIGHT IN THE CEMETERY, BELMONT, USA
52 x 34cm (20½ x 13½in)

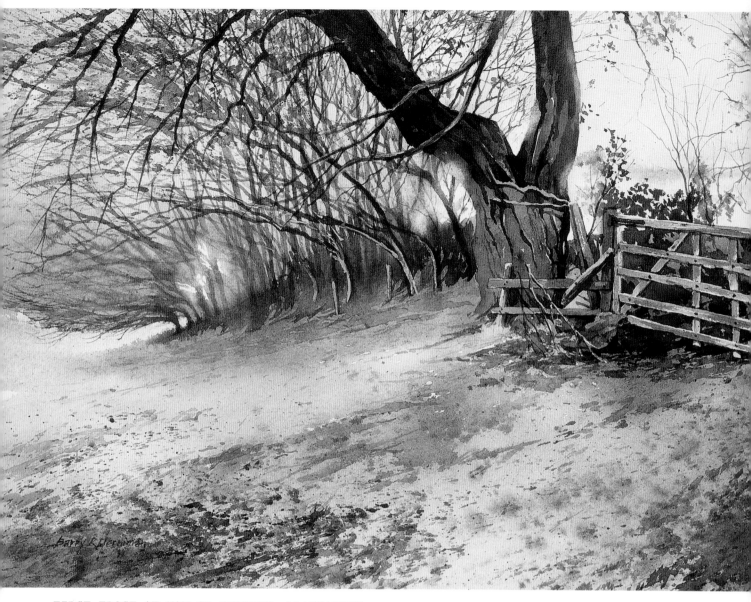

FIRST FROST AT WAY-GO-THROUGH, LLANGARRON
53.5 x 33.5cm (21 x 13¼in)

This painting is reproduced by kind permission of the owners, Jacqs and Ken Anstiss.

First Frost at Way-go-Through, Llangarron, shows a scene on one my favourite routes around the village where I live. It depicts a particular morning after there had been a heavy frost. The early morning sun was just filtering through the trees, infusing intermittent areas with warmth in an otherwise cold scene. I flicked and spattered paint over the foreground making the colours progressively cooler the further they were from the light source.

The painting below is of the same scene, to show how the pervading light can strongly influence the mood and atmosphere of a subject. The painting opposite has a rather warm glow that permeates the whole painting, while the painting below has an altogether much colder feel to it – albeit with a warm glow through the trees where the sun was shining.

Cold Morning Light at Way-go-Through, Llangarron was painted using Schmincke Gouache. This brand has an almost transparent quality when diluted, a great feature in an otherwise opaque medium. My rigger work is in abundance within the tree areas in both paintings.

These scenes, in themselves, are really nothing out of the ordinary. However, they show how different light conditions can 'up-rate' those everyday scenes into something rather special in terms of atmosphere. So, before you spend too much time trying to search out that elusive, picturesque subject, take time to look around you at those oh-so-familiar scenes which are crying out to be painted – poor things; you've bypassed them for so long!

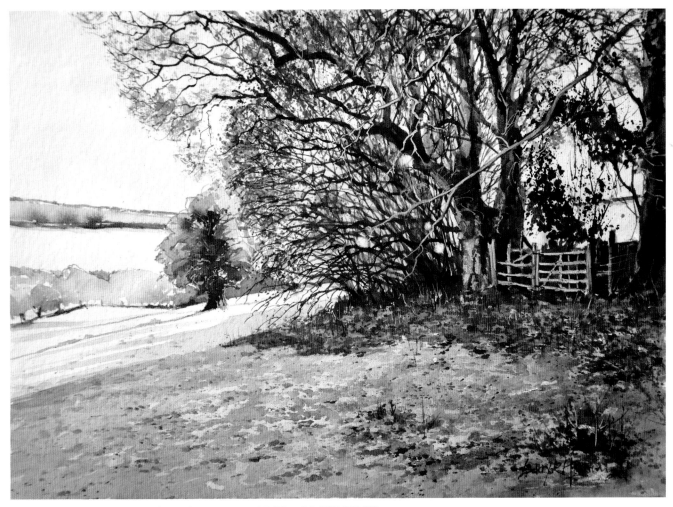

COLD MORNING LIGHT AT WAY-GO-THROUGH, LLANGARRON
38 x 28cm (15 x 11in)

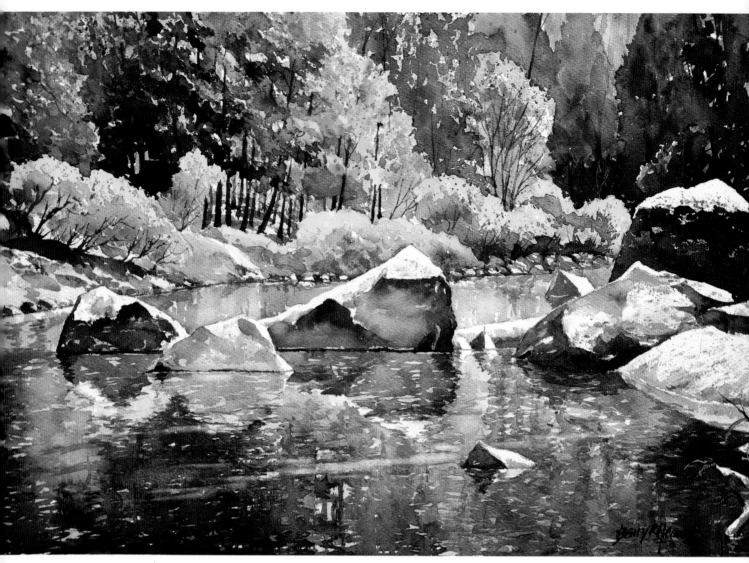

FALL REFLECTIONS, YOSEMITE, USA
56 x 38cm (22 x 15in)

LIGHT AND REFLECTIONS

Reflections are such an important part of rendering a river, stream or lake scene to look like water. Depending on the movement of the water, reflections can add an extra dimension of mood to the scene; emphasizing either stillness or motion.

On one of my painting holidays to the USA we took off into the mountains to experience the wonders of the Yosemite National Park – and what an experience! The vast scale of the place was, to use the American vernacular, 'Awesome'. The colours were jaw-dropping. *Fall Reflections, Yosemite, USA* emerged from this experience. I masked out the tops of the large rocks in the river so I could go a bit wild with the water reflections, dropping in all the glorious fall colours. This meant I could retain all the silvery whites of the rocks. I built up the different depths of colour in the reflections with a series of glazes over dry paint. This way I was able to get the shimmer in the water.

The painting below was made closer to home. Our local farmer had left this field fallow over the winter and there was a lot of old growth still evident. With the heavy frost and the glowing light the whole scene was a patchwork of colour – lights and darks, warms and cools – all dancing together. Notice how the rain-filled tyre tracks reflect the warm glow of the sky. These direct the eye over what would otherwise be a rather bland foreground.

MAKING TRACKS, LLANGARRON
49 x 32cm (19¼ x 12½in)

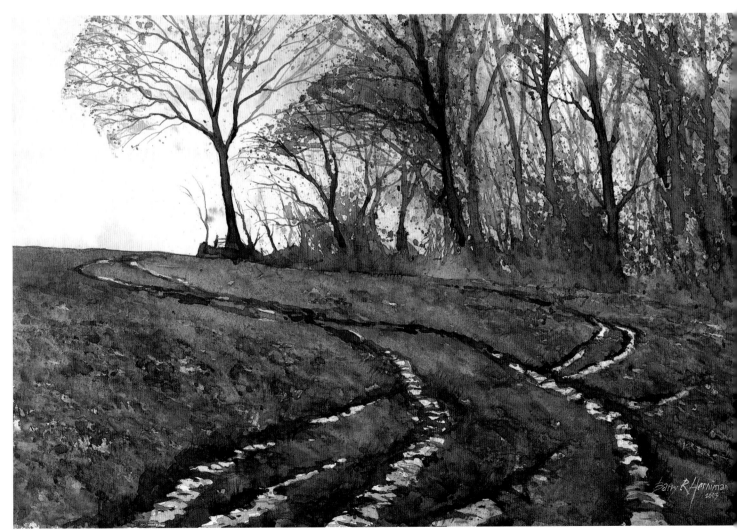

Harbour 'Lights'

I never tire of the Pembrokeshire coast, and Tenby in particular, as it offers a wealth of painting subjects in all weathers. Whenever I am painting down there, I take an early morning stroll on South Beach (when the tide is out) and up into the harbour. On one particular morning the sun had not risen above the rooftops but the pervading light was bouncing about between the houses and alleyways. The whole scene had a warm, rosy glow which was evident even in the shadows.

The sluice, the local name for this dry dock, was almost in total shadow but some of the morning light was filtering between the buildings and lighting up a few details. I wanted to capture the quietness and tranquillity of the small boat moored to the harbour wall, with the two men in casual conversation, one in the boat and the other on the wall.

You will need:

Watercolour paper, Not surface, 640gsm (300lb), 30 x 40cm (11¾ x 15¾in)

Watercolours: aureolin, Indian yellow, madder red dark, rose madder genuine, Winsor red, cobalt blue, French ultramarine, manganese blue, manganese violet, brown madder

Brushes: Nos. 10, 12 and 16 round, No. 3 rigger

White gouache

Water sprayer

Masking fluid and an old brush

Bristle brush

Paper towel

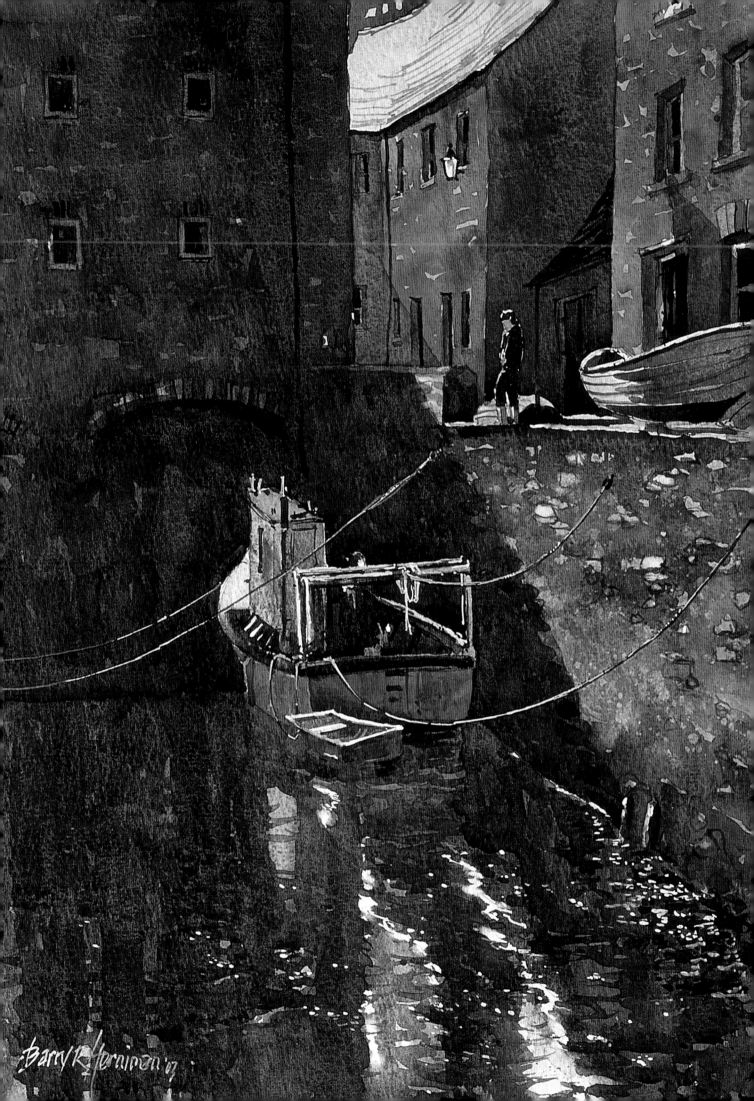

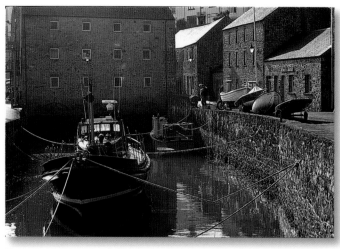

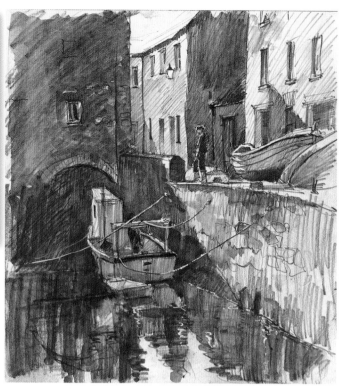

This photograph and the tonal sketch were used as reference material for this step-by-step demonstration.

The overall scene had a rather large lifeboat in the foreground, and there were a lot of mooring ropes cutting across the field of view. These would have made the picture rather messy, so, in the tonal sketch, I closed in on the small boat, simplified the ropes and concentrated on the shapes and tones. I used 2B and 4B water-soluble pencils to draw the sketch on a square block. For the painting, however, I wanted to get a better feeling of depth so I painted it in portrait format.

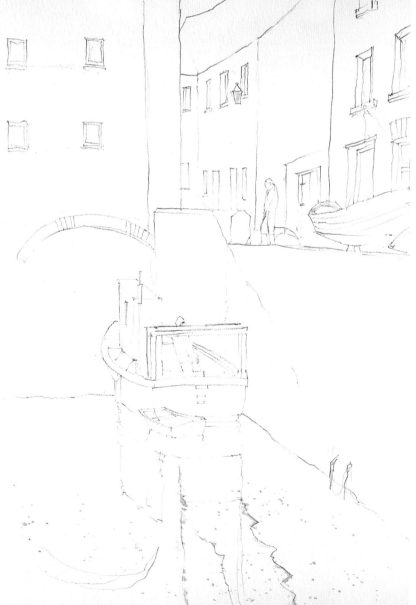

1 Draw in the basic outlines for the composition. Use masking fluid and an old brush to mask the highlights on the boat and dinghy, the figures and the boat on the harbour wall, along the top of the low wall and the lamp. Spatter a few spots on the water below the harbour wall, then mask the edges of the reflections and the edge of the water against the harbour wall. For this project I tinted the masking fluid with a touch of rose madder (a non-staining colour).

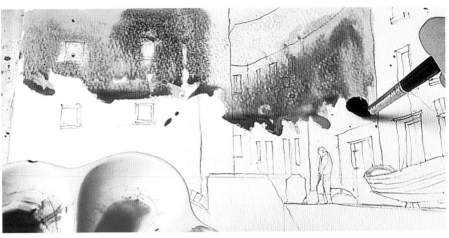

2 Prepare the initial washes: Indian yellow, aureolin, manganese violet, manganese blue, brown madder, rose madder genuine and cobalt blue (see left). Spray clean water over the top of the paper, then, working quickly wet in wet, start to lay in the initial washes of colour.

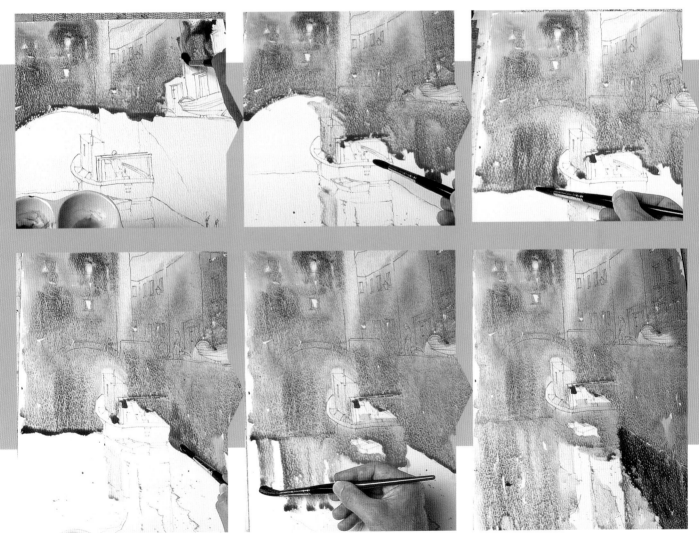

3 Now it is all about speed and vitality. While the paper is still wet, pull and push colour all the way down the painting, dropping in cold accents here and there – on the boat and in the reflection. Keep the colours strong and vibrant, as they will lighten considerably as they dry. Do not worry about colours going where they should not; this can be dealt with at a later stage.

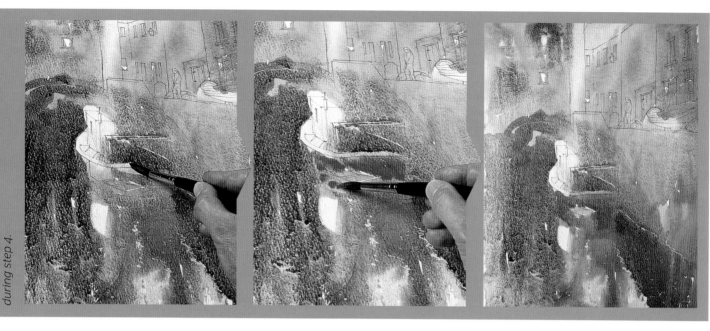

4 Complete the initial washes by adding colour to the boat, then leave until thoroughly dry.

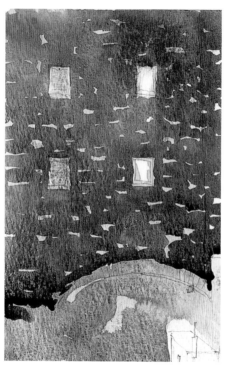

5 Using the No. 12 brush with cobalt blue and brown madder, and working wet on dry, work up the shadowed wall of the building at top left, cutting round the windows (see above). Add touches of manganese violet but leave some of the background colours as highlights on the stonework (see right).

6 Work the darks under the arch with French ultramarine, cobalt blue and brown madder. Pull down the darks in the wet bead of colour above the arch to suggest brickwork.

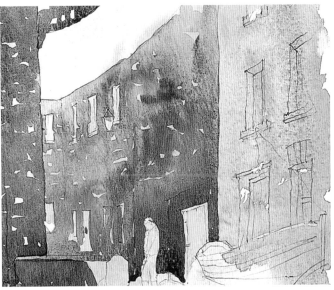

7 Bring the colours down to the water's edge, then introduce cooler tones at the left-hand side. Cutting round the shape of the boat, use the same colours to create the cast shadow on the harbour wall, but add more blue as you work forward.

8 Use Indian yellow and brown madder to paint the sunlit walls of the buildings at the top right; again, cut around the windows and leave some of the undercolour shining through. Add touches of manganese blue here and there to cool some areas. Use cooler tones to add the distant buildings at the top left-hand corner of the composition.

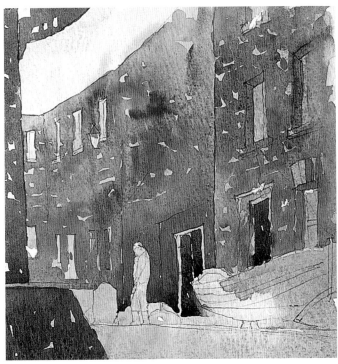

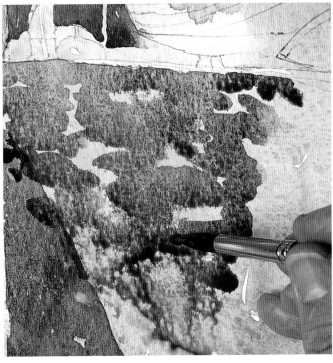

9 Use the same colours but with more Indian yellow to work up the right-hand building. Use manganese violet to paint the two doors.

10 Spatter water on the harbour wall, then, using cobalt blue and brown madder, touch a loaded brush gently on the paper and allow the colours to disperse randomly, creating hard and soft edges.

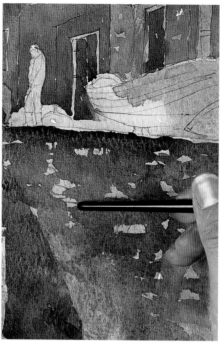
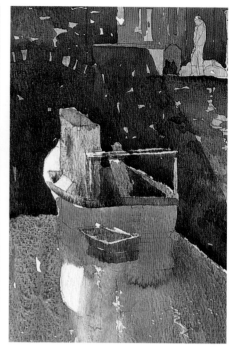

11 Spatter aureolin and manganese blue on the lower part of the wall, followed by brown madder and cobalt blue just above the water line. Turn the painting upside down and drop in more colour and allow a bead to form to define the hard edge along the top of the harbour wall.

12 While the colours are still wet, use the handle of the brush to indicate mortar joints between the blocks of stone, then leave to dry.

13 Use manganese blue and manganese violet to paint the left-hand side and back of the boat's superstructure, and the inside of the dinghy. Use brown madder, cobalt blue and a touch of manganese violet for the shadows in the stern of the boat. Paint the cabin roof with aureolin and madder red dark. Use brown madder to paint the side and stern of the dinghy, then add a touch of cobalt blue to the brown for the reflection.

122

These images show the progression of colours during step 14.

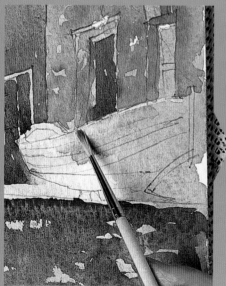

14 When I laid in the initial washes, I allowed some colour to spread over the boat sat upon the harbour wall. On reflection, this should be removed. Use a small bristle brush and clean water to wet the unwanted colour, use a clean piece of paper towel to lift it off the paper, then use manganese blue and manganese violet to block in the side and inside stern of the boat.

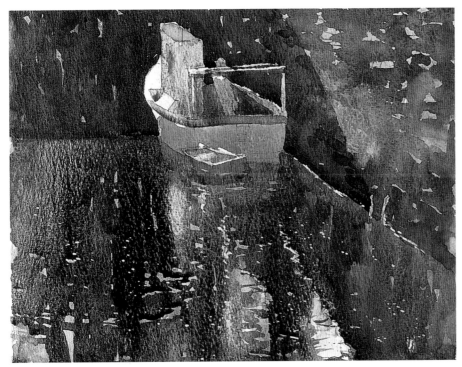

15 Brush a few vertical bands of clean water on the area of water, then, starting at the water line against the far building, lay in reflected colours with touches of cobalt blue, brown madder and manganese violet and allow them to blend. Add a few horizontal squiggles in the foreground. Drop some French ultramarine and aureolin into the reflection of the harbour wall at the right-hand side. Apply a weak cool wash over the orange reflection of boat. Use the handle of the brush to create fine ripples in the reflections.

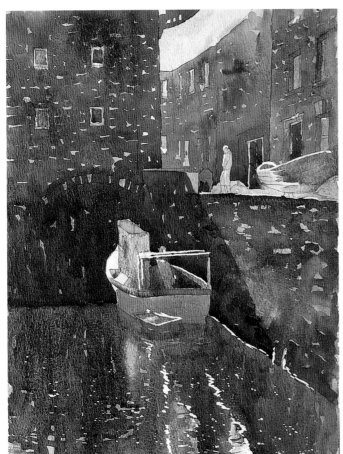

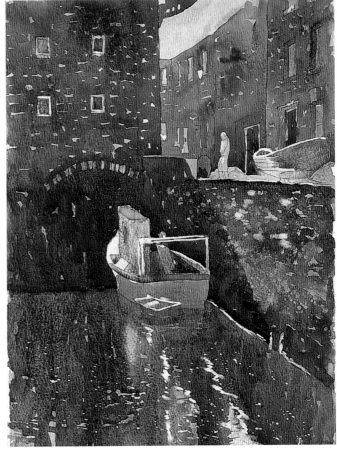

16 Allow to dry completely, then remove all the masking fluid to reveal the saved whites.

17 Referring to step 14, use clean water, a bristle brush and paper towel to soften some of the hard edges created by the masking fluid on the water and the boat. Lift out colour from the windows and from the brickwork in the arch and harbour wall. Spatter water over the harbour wall, leave for a few seconds, then lift out some of the colour to create small areas of soft highlights.

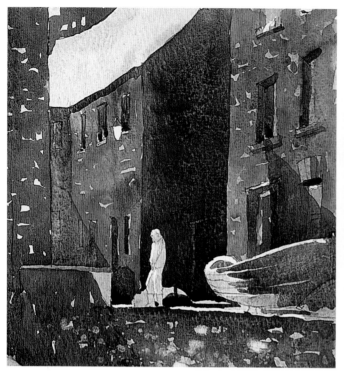

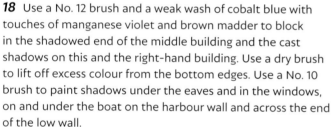

18 Use a No. 12 brush and a weak wash of cobalt blue with touches of manganese violet and brown madder to block in the shadowed end of the middle building and the cast shadows on this and the right-hand building. Use a dry brush to lift off excess colour from the bottom edges. Use a No. 10 brush to paint shadows under the eaves and in the windows, on and under the boat on the harbour wall and across the end of the low wall.

19 Using a No. 16 brush with French ultramarine, cobalt blue and brown madder, and starting at the top of the left-hand building, pull the colours down the paper to the bottom of the wall. Cut round the boat shape. Bring the same colours down through the water with broad vertical strokes, then work some narrow horizontal ones. Add a few squiggles of darker tones in the bottom right-hand corner. Leave until the paint is completely dry.

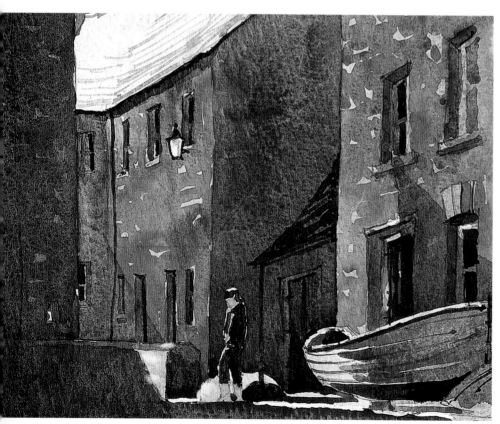

20 Dipping into each colour in turn, load a No. 3 rigger with French ultramarine, brown madder and cobalt blue, then add dark shadows under the eaves and round the windows and doors. Use the same colours to develop the shape of the lamp and the roof of the lean-to between the buildings. Use cobalt blue and Winsor red to develop the dark shadows on the boat. Use the same colours to block in the clothes of the figure, leaving some of the undercolour as highlight. Use manganese blue to add texture on the roof, then add a touch of this colour to the glass of the lamp. Use Indian yellow for the highlights on the boat and the man's boots.

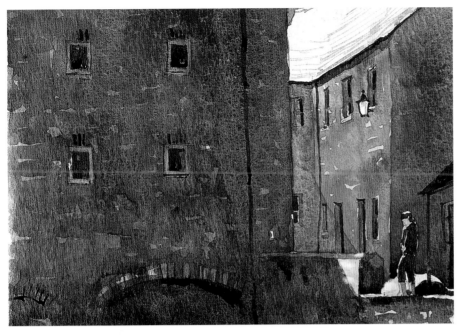

21 Add darks in the windows of the left-hand building. Indicate a few bricks over the windows and add the drain pipe. Develop the deep shadow under the arch and add a couple of dark patches on the low wall.

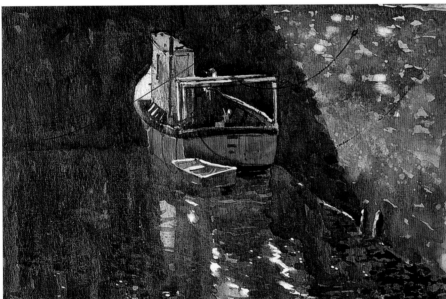

22 Apply a wash of Indian yellow on the white highlights on the boat. Using a dark mix on the palette, paint the mooring ring on the harbour wall and the mooring ropes. Develop the shadowed stern of the boat with Indian yellow, cobalt blue and a touch of brown madder. Darken the area behind the dinghy with more cobalt blue and develop the shadows with darks from the palette. Use manganese blue with a touch of Winsor red to paint shadows on the cabin, then use the darks on the palette to define detail inside the hull of the boat. Add the same darks to the reflections at bottom right.

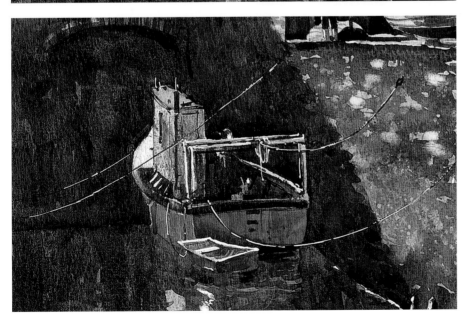

23 Finally, use white gouache to add fine, bright highlights on all the mooring ropes.

The finished painting can be seen on page 117.

BOATS AND HARBOURS

Boats make wonderful subjects, but they can be quite daunting when you first look at all the lines and details. I tend to simplify things a lot. I concentrate more on the main structures, then, when I am happy with those, I use a rigger brush to 'tick' in a few fine details.

When I make a visit to the Leven Art Society, I always revel in the beauty of North Yorkshire. One of my favourite haunts is the quaint village of Staithes, set in a small, sheltered cove at the base of a cliff. The local fishing boats, cobles, are moored up in the harbour with a web of mooring lines criss-crossing the scene. I ticked these ropes in with white gouache and a rigger right at the end of the painting process for *Boats in the Beck, Staithes*, below.

Harbours are often interesting visually, with a mix of open areas and tighter structural detail in the boats. Whenever I visit Tenby in Wales, I endeavour to take an early-morning walk around the harbour. At low tide, you can walk on the sand between the tied-up boats. From this viewpoint, looking up at the boats and the buildings beyond, you get a completely different slant on the scene; a slant shown in the painting opposite.

The small rivulets of water and the criss-cross pattern of the mooring ropes and chains make a pleasing detail in the foreground that helps lead the eye into the picture. The main area of light is between the two buildings, top left, and this reflects nicely into the water on the sand.

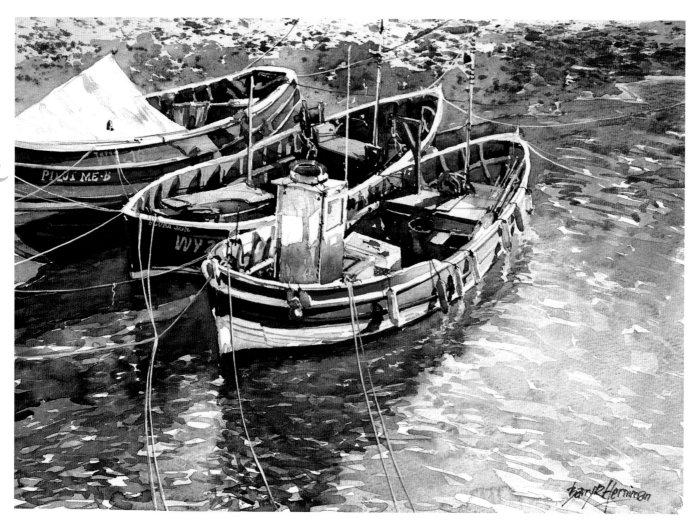

BOATS IN THE BECK, STAITHES
38 x 28cm (15 x 11in)

Opposite
MORNING LIGHT, TENBY HARBOUR
35 x 53.5cm (13¾ x 21in)

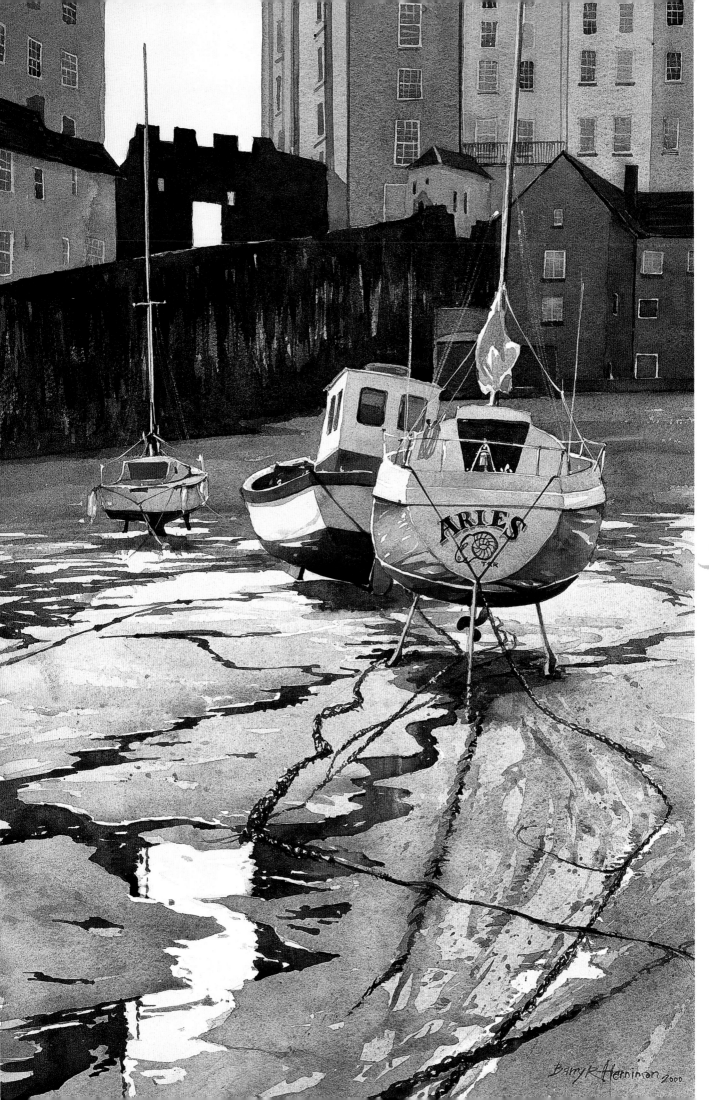

INDEX

128

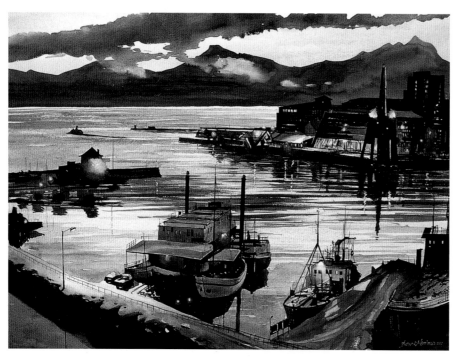

AS LIGHT AS IT GETS, TROMSØ HARBOUR

68.5 x 48.5cm (27 x 19in)

The city of Tromsø is in the far north of Norway, above the Arctic Circle. I was only there for three days but in that time I never saw the sun; just this lovely glow around midday, then darkness again – most weird! Because of this, there are always lots of lights casting their multicoloured glows over the snow-covered land.